DEER
The Ultimate Artist's Reference

A superb eight-point white-tailed buck rests
in the shade during a hot November after-
noon in southern Texas

DEER
The Ultimate Artist's Reference
By Doug Lindstrand

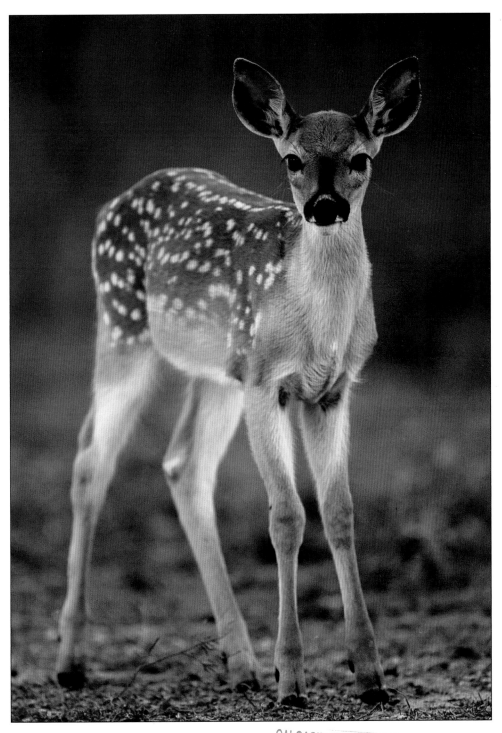

Fox
Chapel Publishing Co. Inc.

1970 Broad Street • East Petersburg, PA 17520 • www.foxchapelpublishing.com

Dedicated to all wildlife artists.

Publisher	Alan Giagnocavo
Book Editor	Ayleen Stellhorn
Cover Design	Jon Deck
Desktop Specialist	Linda Eberly, Eberly Design, Inc.

ISBN 1–56523–195–3
Library of Congress Preassigned Card No: 2003107292

To order your copy of this book,
please send check or money order
for the cover price plus $3.50 shipping to:
Fox Chapel Publishing Company, Inc.
Book Orders
1970 Broad St.
East Petersburg, PA 17520

Or visit us on the web at
www.foxchapelpublishing.com

Printed in China
10 9 8 7 6 5 4 3 2 1

Mule deer, buck (Utah)

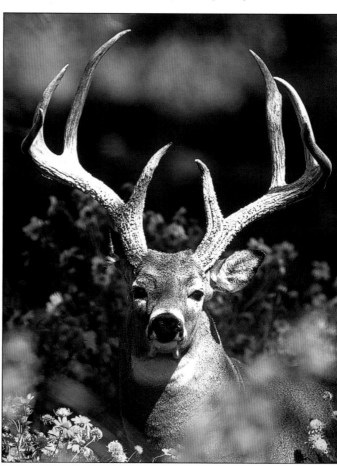

White-tailed, buck (Texas)

Table of Contents

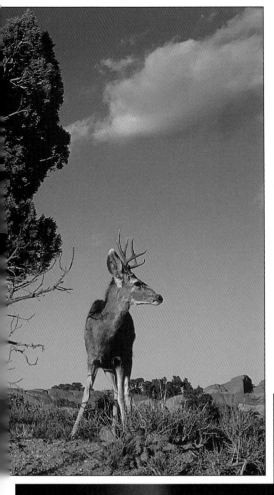

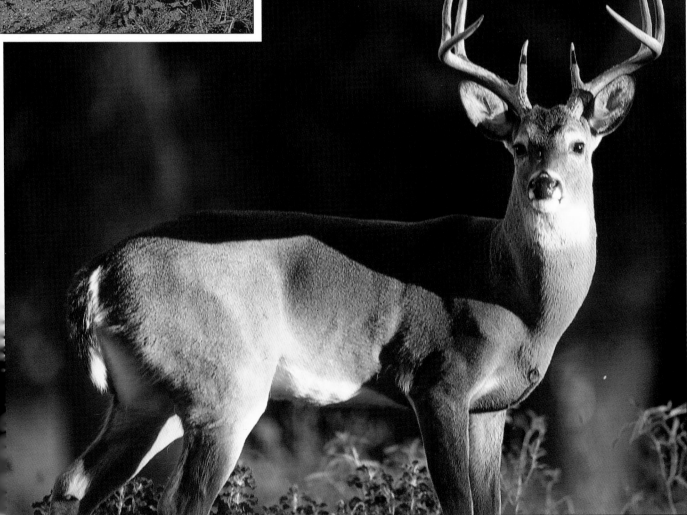

White-tailed deer, buck (October/Texas)

Artist's Comments

The photographs in *Deer: The Ultimate Artist's Reference*, were taken as I traveled North America from Alaska to Key West, Florida, and from Canada to northern Mexico. The sketches were made in the field, at base camps, and also at my Alaska studio.

The deer is probably the animal most often drawn, carved or painted by wildlife artists. Also, because bucks with antlers are usually portrayed, I concentrated on drawing them for this reference guide. My hope is that this book may be helpful to those who do not have the opportunity to acquire this research material for themselves.

Happy Trails and Good Drawing,

Doug Lindstrand

The author, Doug Lindstrand, at work in the Chugach Mountains, Alaska

Introduction

The deer family (*Cervidae*) of North America consists of moose, caribou and elk, as well as the mammals of the genus *Odocoileus*, more commonly called deer. The deer of North America—black-tailed, mule and white-tailed—are the subjects of this book.

I have found that it is somewhat difficult to accurately portray an animal that is distributed over such a broad geographical area. It quickly becomes evident that no two deer seem to look alike and that southern deer differ greatly from their northern counterparts. Colors, sizes and antlers all vary. I have tried, therefore, to record locations and dates with many of the drawings and photographs.

Although the black-tailed deer is considered a subspecies of the mule deer, I have separated it for the purpose of this book. The book will therefore be broken down into three sections: the black-tailed deer, the mule deer, and the white-tailed deer.

My primary goal for this reference guide is to show (through art and photographs) the North American deer at different ages in various seasons and poses. This will, in turn, help artists to portray these animals in their own artwork with greater accuracy. Because this book is intended as a reference guide for artists, I purposely chose to make it mostly visual with art and photographs and to forsake most biological and environmental facets of a deer's life.

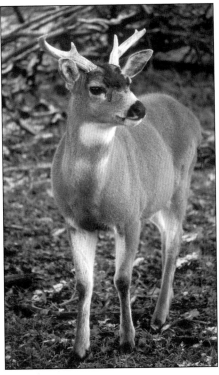

Black-tailed deer

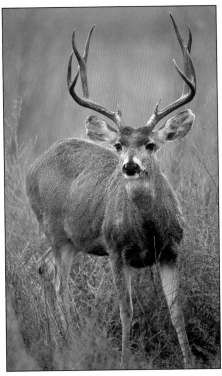

Mule deer

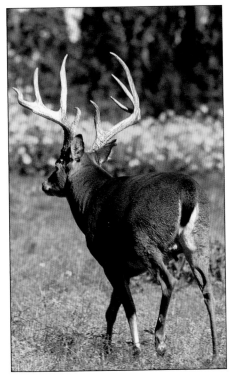

White-tailed deer

• It is usually easy to distinguish the antlers of a mule deer from those of the white-tailed deer because of the double forking of the main beams.

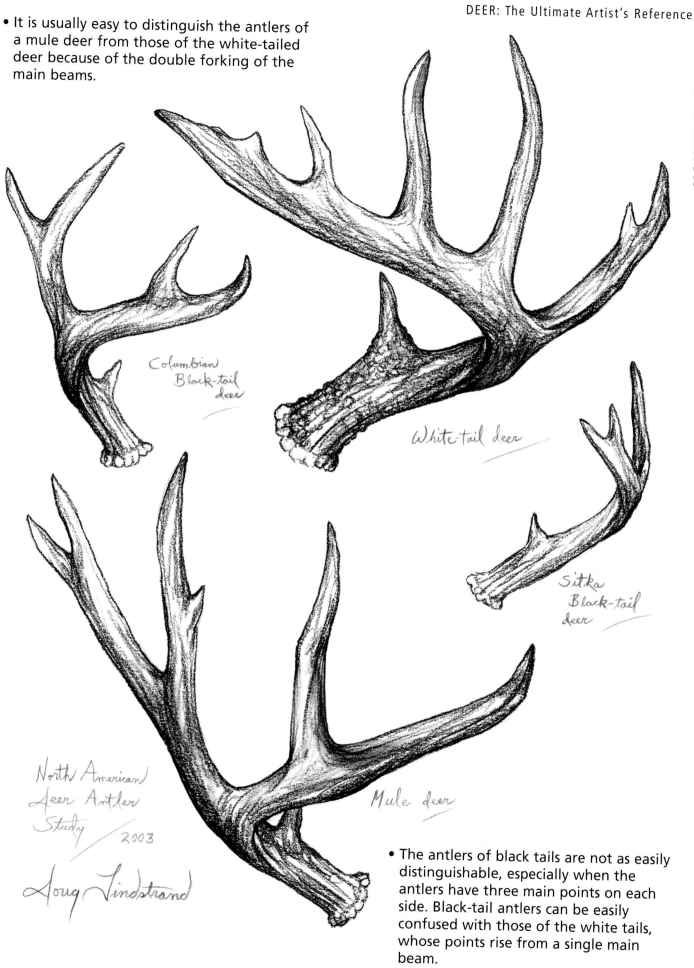

Columbian Black-tail deer

White-tail deer

Sitka Black-tail deer

North American Deer Antler Study / 2003

Doug Lindstrand

Mule deer

• The antlers of black tails are not as easily distinguishable, especially when the antlers have three main points on each side. Black-tail antlers can be easily confused with those of the white tails, whose points rise from a single main beam.

King of the Forest. Wood cut on a scroll saw by Lora S. Irish.

Deer. Wood carving. Carver unknown.

Mule deer (detail). Wood carving by Todd Swaim.

White-tailed deer. Wood carving by Todd Swaim.

Mule deer. Wood carving by Todd Swaim.

Deer. Relief carving in wood by Lora S. Irish.

Forest scene. Intarsia by Judy Gale Roberts.

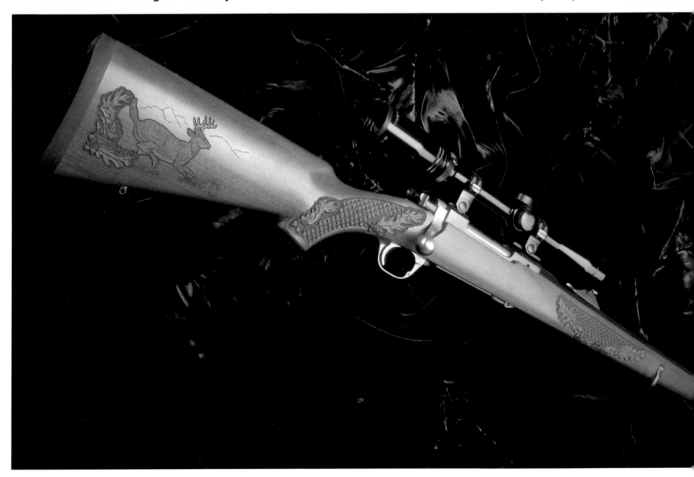

Deer. Engraved wooden gunstock by Bill Janney.

Deer of North America

The deer of North America range from central Canada south to Panama. Its genus, *Odocoileus*, is generally considered to include only two species: the white-tailed deer (*O. virginianus*) and the mule deer (*O. hemionus*). The Sitka black-tailed deer (*O.h. sitkensis*) and the Columbian black-tailed deer (*O.h. columbianus*) are subspecies of the mule deer species. All members of *Odocoileus* can interbreed, so identification of the many subspecies can often be virtually impossible to an observer. Tails, geography and antlers, however, are usually enough to distinguish white tails from mule deer and also from black tails.

White-tailed Deer

White-tailed deer (also called white tails or flag-tails) are found throughout much of North America. No white tails presently reside in Alaska or in certain areas of the American southwest. They are the most numerous of the deer species and are estimated to number over twenty million. There are 30 recognized subspecies of white tails, and they vary widely in size from the large northern deer to the small southern deer of southern Arizona, Mexico, and the Florida Keys.

The mating season of the white-tailed deer runs from November to January, and the young are usually born between May and July. Young does will usually produce a single fawn initially but thereafter will normally have twins and an occasional set of triplets. The gestation period is six and one-half months, and the spotted, reddish-colored fawns weigh about five to seven pounds at birth. They will remain hidden throughout most of their first few weeks of life in order to evade the predators that roam their range. At three weeks of age they begin to eat vegetation but continue to nurse three or four times daily until winter.

A white-tailed deer's pelage is reddish-tan during the summer months and grayish-tan during much of the remainder of the year. Also, northern deer are generally darker than their southern counterparts.

White tails sport white on their chins, throats, and bellies, around their eyes, and on the insides of their ears and legs. The name, white-tailed deer, comes from the white underside of its tail, which is displays as a sort of flag when alarmed. Other displays of alarm include stomping hooves and snorting.

The white tail's antler-growing season is from late March to August. Velvet, which is actually a blood-filled skin that covers the antlers during this time, is then shed in August and September, and the antlers are usually shed between January and March. These sheds are utilized by small animals as a source of needed minerals and are chewed away within a few years. The largest, breeding bucks normally shed their antlers before the young, non-breeding bucks. The bucks become much more docile and once again begin to feed in earnest in order to regain the strength lost during the annual rut.

Mule Deer

The mule deer, or muley as it is sometimes called, populates much of the western half of North America. It is much more of a "wilderness" species, inhabiting the mountains, high plains and deserts, than is the white-tailed deer. The black-tailed deer subspecies is found predominantly along the western coast of British Columbia, Washington, Oregon, northern California and southeastern Alaska. There are about six million mule/black-tailed deer in North America, and certain studies have indicated that mule deer are losing out to the ever-expanding white tails in many regions.

There are eleven recognized subspecies of the mule deer, and they range in size from the large Rocky Mountain deer to the smaller and paler desert deer. Black tails are usually smaller, too.

The northern mule deer will usually have a rutting season that begins a little earlier than its southern counterparts, and the birth of the large-eared, long-legged, spotted fawns will occur about six and one-half months later. Male fawns are often 10 to 20 percent

larger than female fawns, and all healthy fawns will double their birth weight in about two weeks and weigh ten times as much in six months.

Mule deer's summer coats are reddish-brown above with a creamy-tan belly; winter coats are grayish above. They also sport a white throat patch, white chin, white rump and white inside their ears and legs. Their antlers are normally branched equally, each a separate beam forking into two tines. A white-tailed deer, in contrast, has antlers with a single beam from which numerous tines protrude. In addition to the antler difference, mule deer are also distinguished by their black-tipped, rope-like tail and by their large mule-like ears. When running across rough terrain, they will revert to a stiff-legged, bounding gait.

Black-tailed Deer

As mentioned previously, black-tailed deer are members of the mule deer species and are found more toward North America's western coast. Black tails are generally smaller than the mule deer, and although

bucks have the same antler configuration as muleys, the black tails do have a tail that—although blacker on top—is somewhat similar to the white tails.

The Sitka black-tailed deer bucks weigh 150 to 185 pounds, and does will average around 100 pounds. Columbian black tails are a little larger, less stocky and have slightly longer faces than Sitkas. Sitkas are native to the coastal rain forests of southeast Alaska and British Columbia, and the Columbians reside from southern British Columbia south to central California. There is likely a lot of interbreeding among the various subspecies that inhabit this region. I uncovered many probable crosses in my travels.

All deer populations fluctuate widely depending upon the severity of weather, predators and hunting. Parasites and diseases are also a determinant. Few deer live to their third year and, therefore, never reach their full body size (usually around five years of age). The bucks also never reach their largest antler potential, which usually occurs between five and eight years.

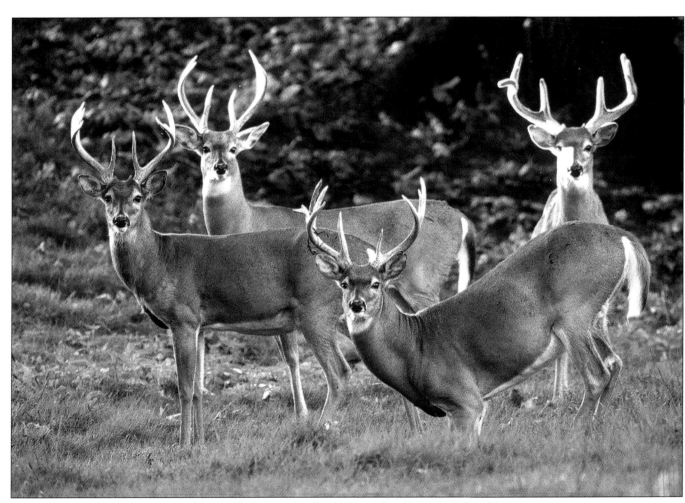

White-tailed deer, bucks (September/British Columbia)

Black-tailed Deer

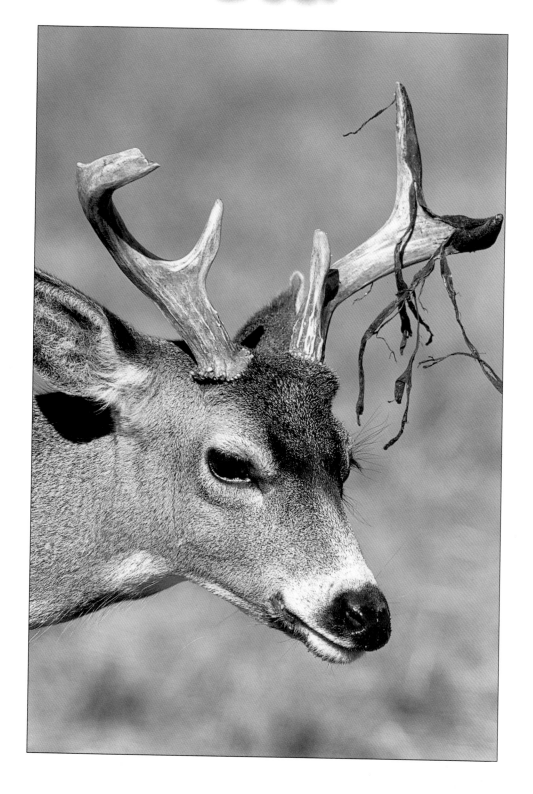

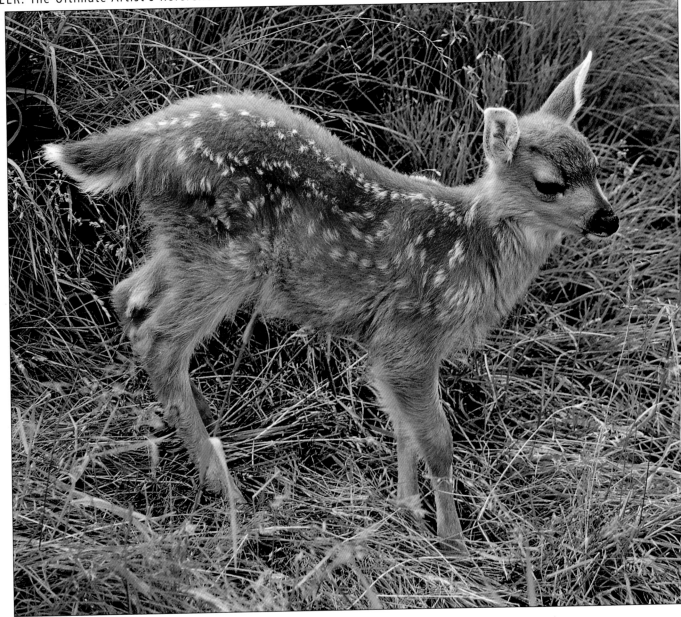

Sitka black-tailed deer, fawn (June)

The mating season of the Sitka black-tailed deer is October and November. Fawns are normally born in May or June. Their birth often occurs in the fringes of trees and brush adjacent to a beach or lowland muskeg.

Legs of fawns are much longer at birth in relation to their body than they will be in later life. Fawns are usually nursed three or four times daily and begin to eat vegetation at about three weeks of age. Their red-dish-colored coats are dotted with spots that provide excellent camouflage as they lie motionless in cover. Fawns have two rows of whitish spots running down both sides of their spine, and there are a total of 60 or 70 spots overall. These spots are usually gone by August. By this time, the fawns are able to rely more on their speed to escape predators than on their hiding ability.

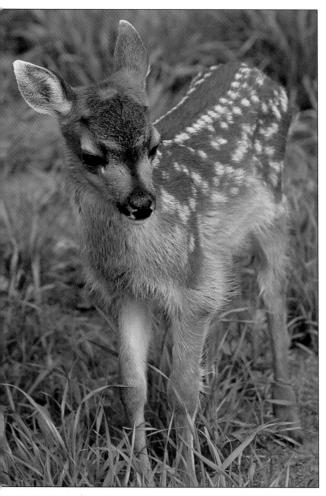

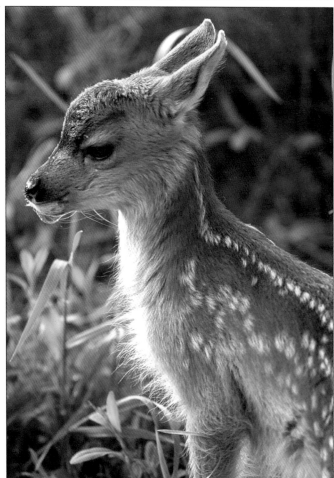

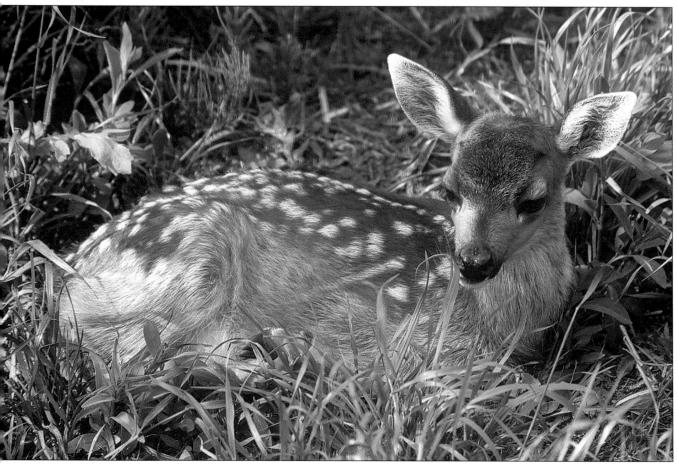

Sitka black-tailed deer, fawns (June)

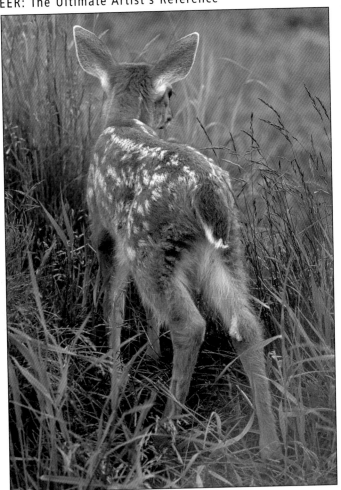

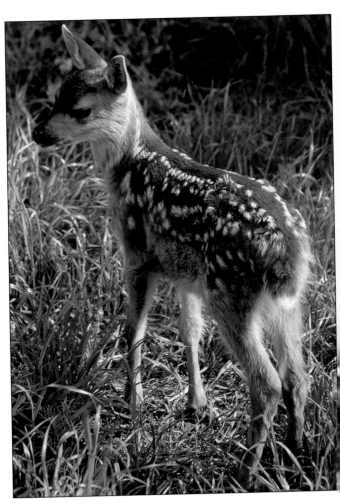

Sitka black-tailed deer, fawns (June)

• Black-tailed deer fawns are born in May and June and weigh about six to eight pounds at birth.

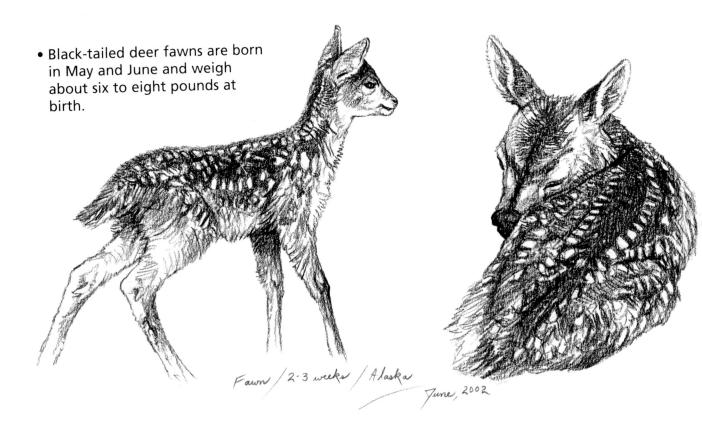

Fawn / 2-3 weeks / Alaska

June, 2002

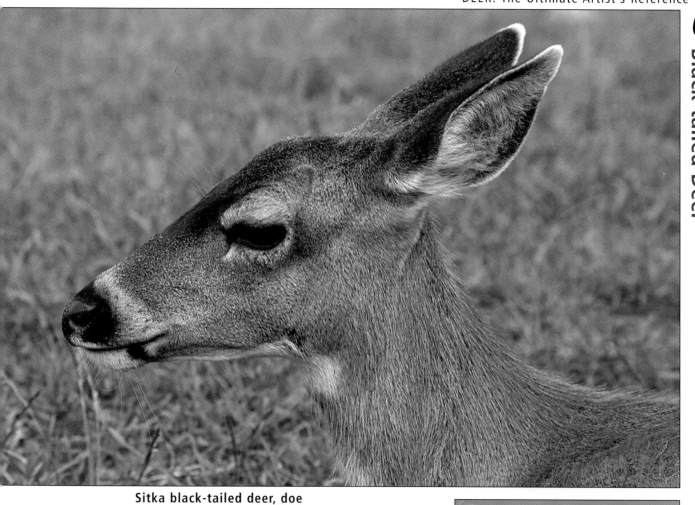

Sitka black-tailed deer, doe

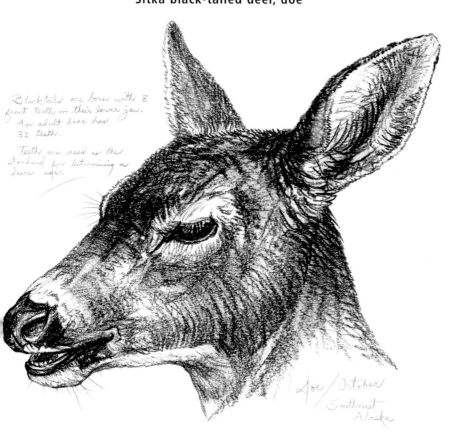

Black-tails are born with 8 front teeth in their lower jaw. An adult deer has 32 teeth.

Teeth are used as the standard for determining a deer's age.

Doe / October
Southeast
Alaska

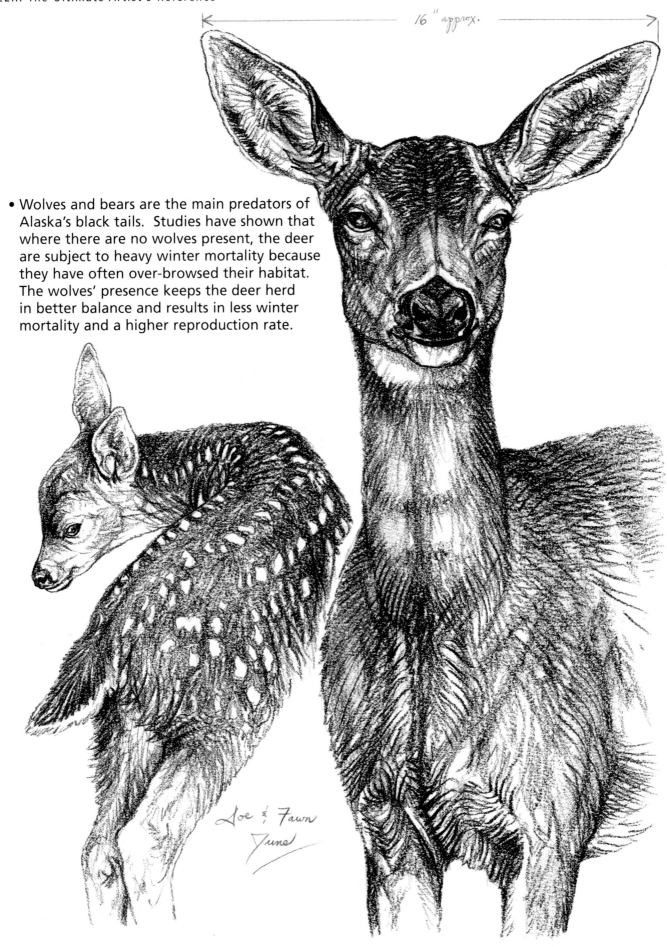

16 " approx.

• Wolves and bears are the main predators of Alaska's black tails. Studies have shown that where there are no wolves present, the deer are subject to heavy winter mortality because they have often over-browsed their habitat. The wolves' presence keeps the deer herd in better balance and results in less winter mortality and a higher reproduction rate.

Joe & Fawn
June

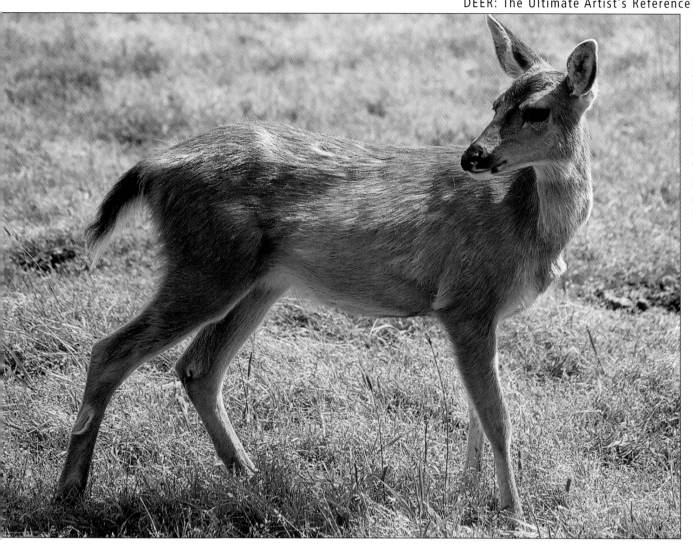

Sitka black-tailed deer, doe

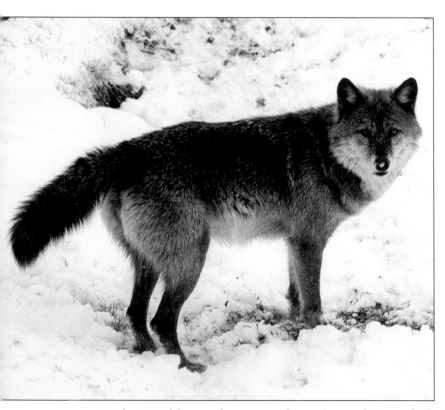

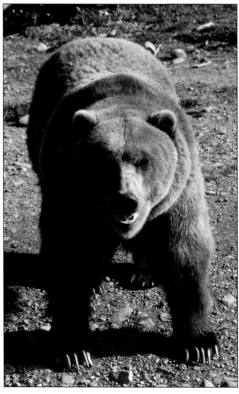

Wolves and brown bears are the main predators of Alaska's black-tailed deer.

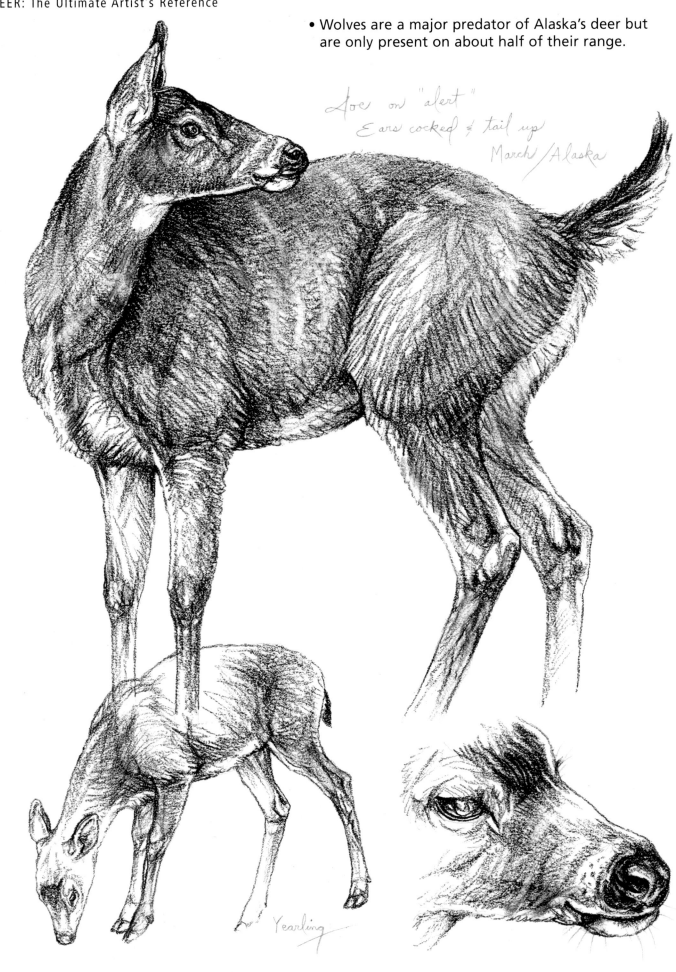

Black-tailed Deer

• Wolves are a major predator of Alaska's deer but are only present on about half of their range.

Doe on "alert"
Ears cocked & tail up
March/Alaska

Yearling

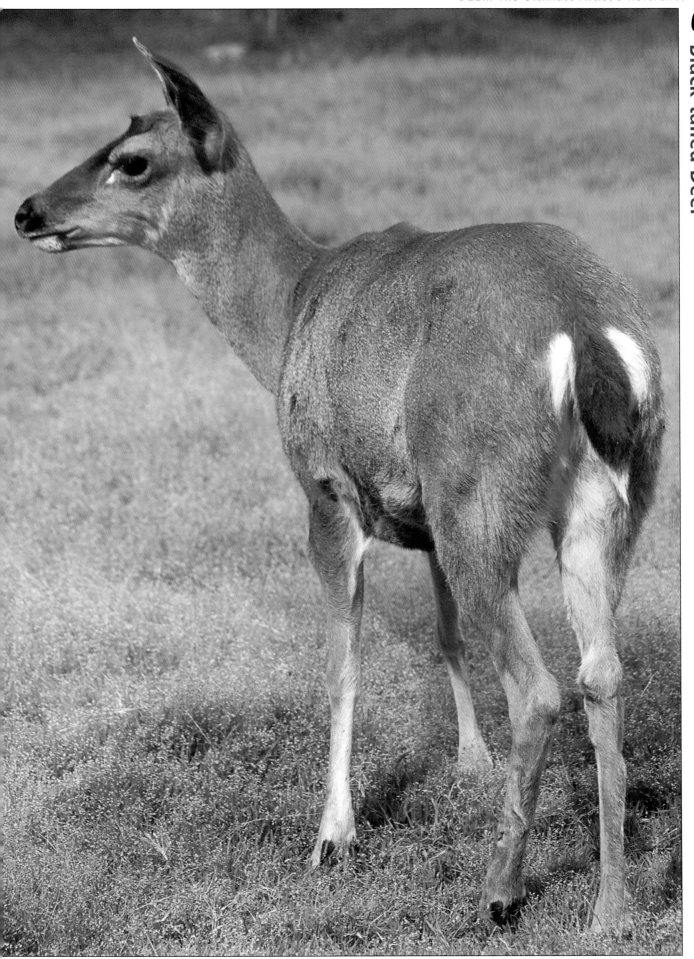

Sitka black-tailed deer, doe (July/Alaska)

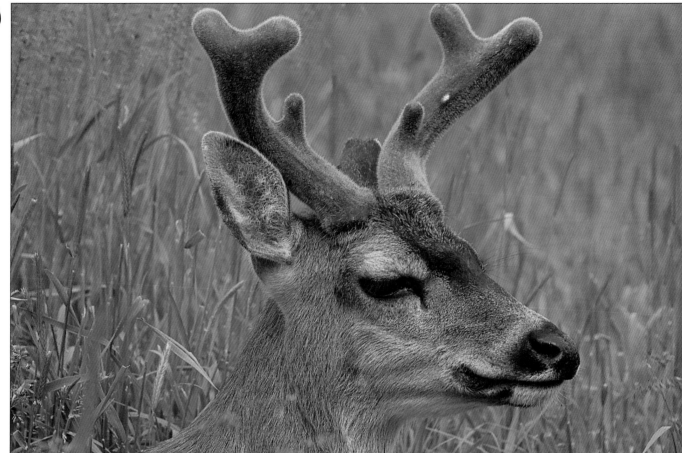

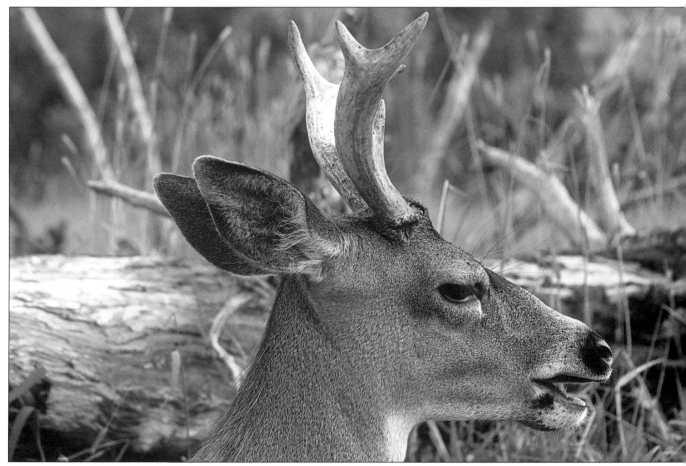

Summer coats of the Sitka black-tailed deer are reddish-brown and turn to gray during the winter months. Antlers are light brown and have the typical black-tail branching. (Top photo: July. Bottom photo: August)

• A mature buck will weigh between 150 and 185 pounds on average.

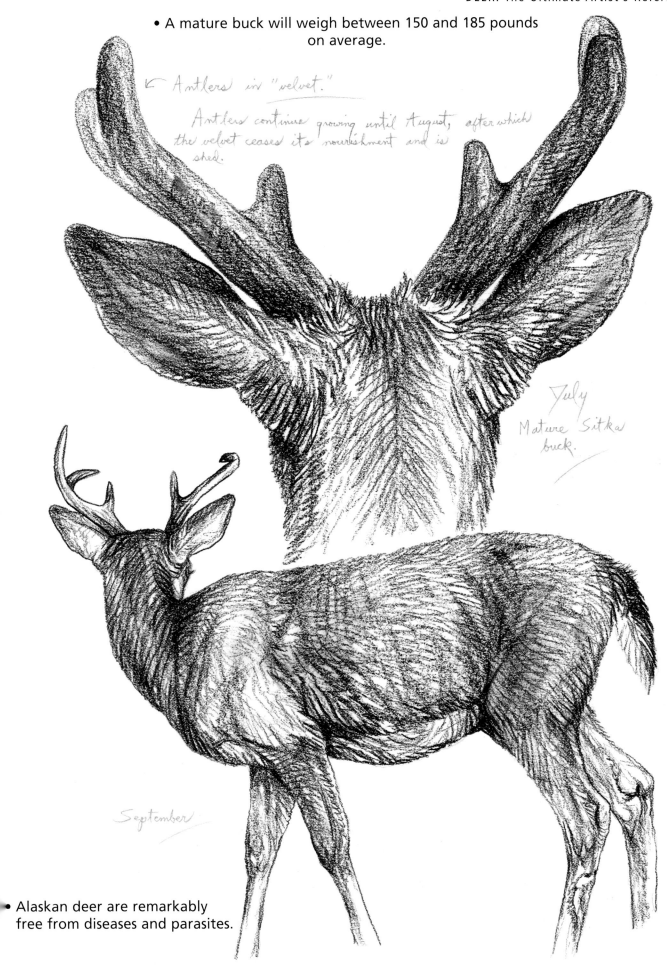

← Antlers in "velvet."

Antlers continue growing until August, after which the velvet ceases its nourishment and is shed.

July
Mature Sitka buck.

September

• Alaskan deer are remarkably free from diseases and parasites.

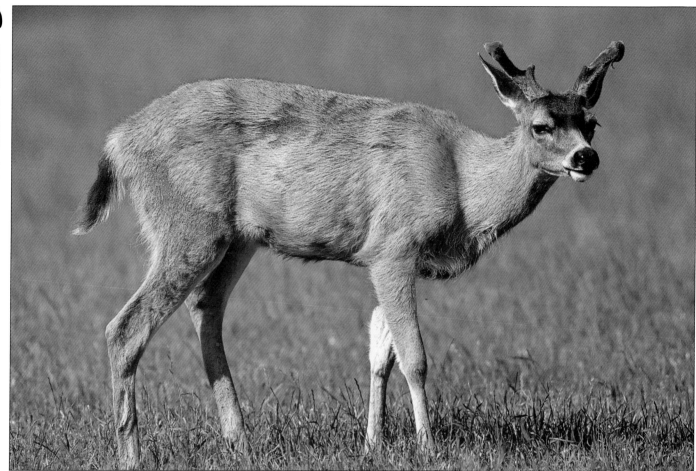

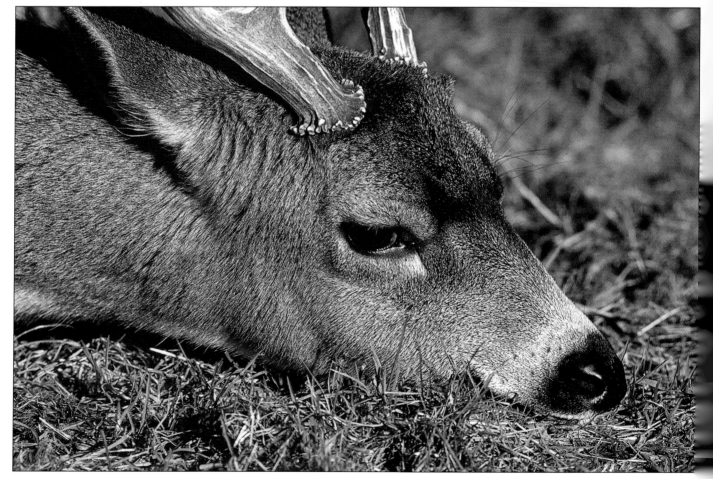

Sitka black-tailed deer, bucks (Top photo: August. Bottom photo: October)

• The Sitka black-tailed deer has a shorter face and is smaller and stockier than the Columbian black tail.

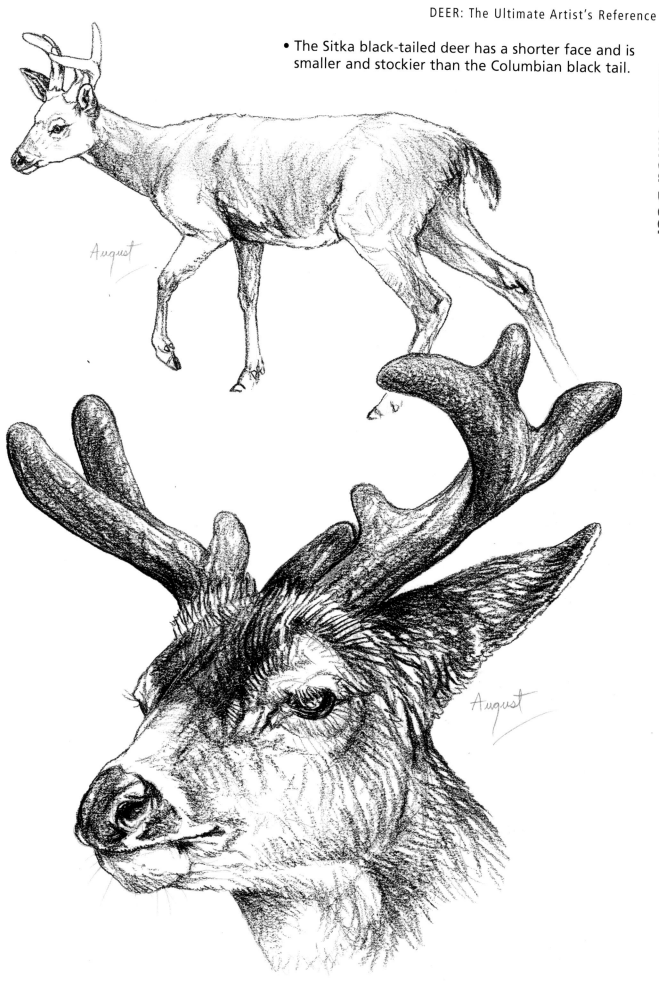

August

August

Black-tailed Deer

- The Sitka black-tailed deer is native to the coastal rain forests of southeast Alaska and coastal British Columbia.

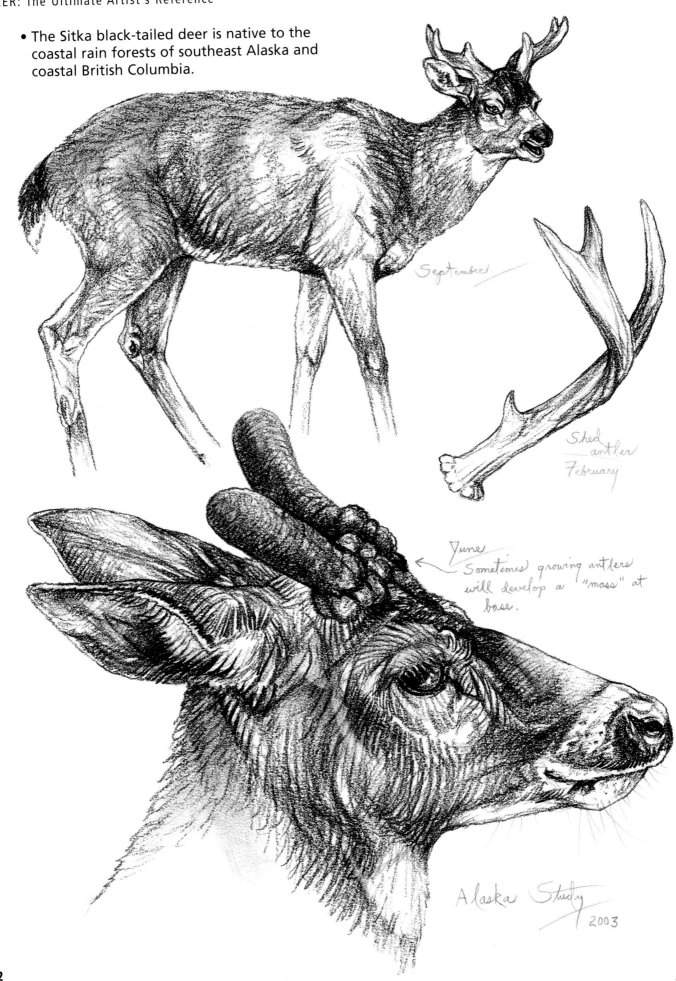

September

Shed antler February

June
Sometimes growing antlers will develop a "mass" at base.

Alaska Study 2003

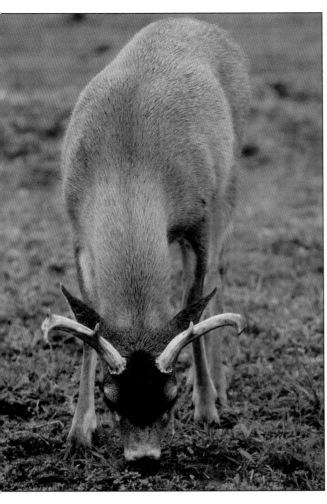

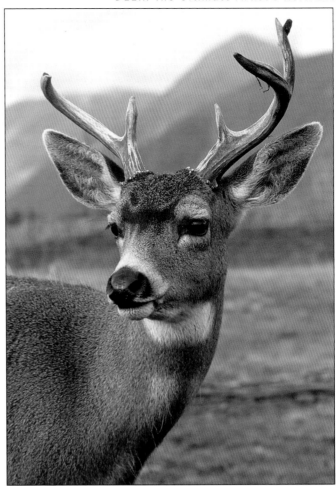

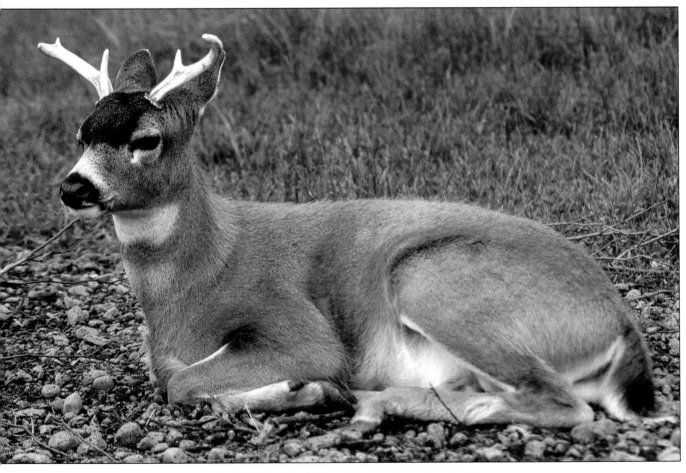

Sitka black-tailed deer (September, October)

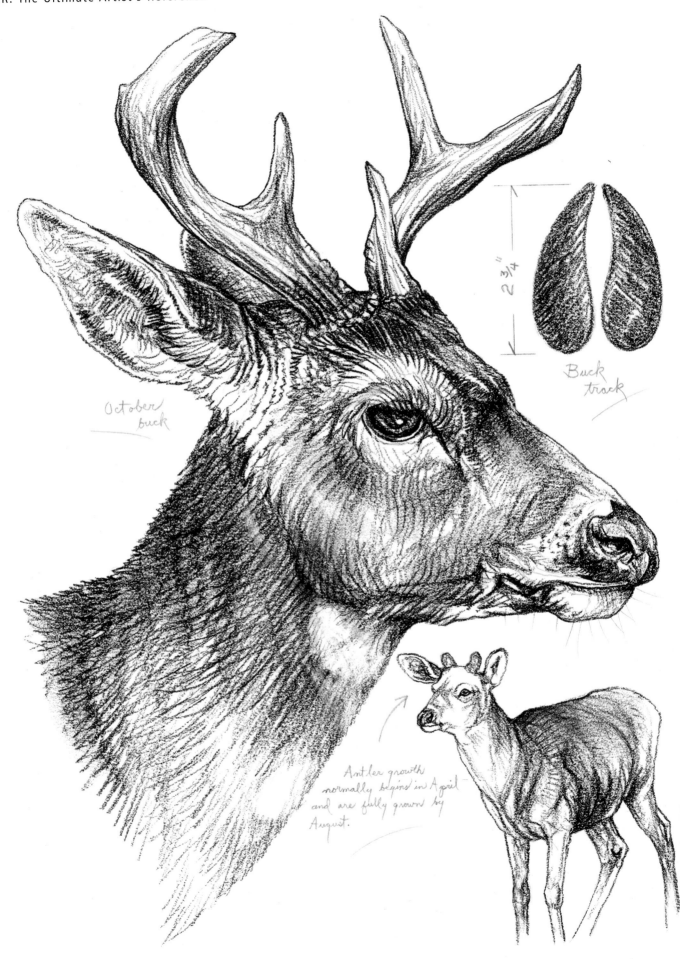

Black-tailed Deer

2 3/4"

Buck track

October buck

Antler growth normally begins in April and are fully grown by August.

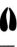

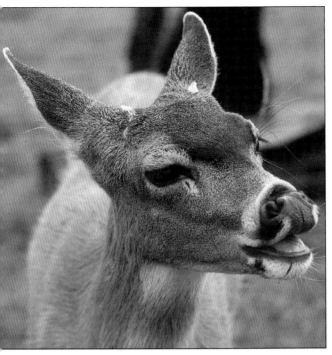

Although this is a mature deer (above), photographed in August when antler growth has peaked, an injury may have prevented its antlers from growing.

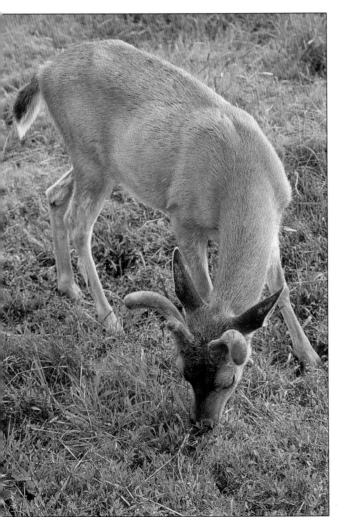

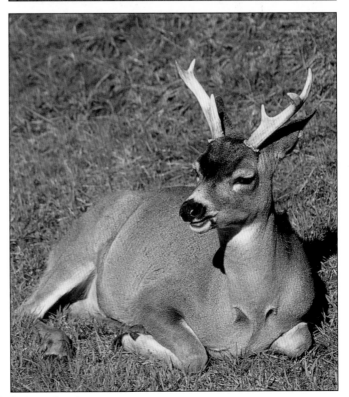

Sitka Black-tailed deer, bucks

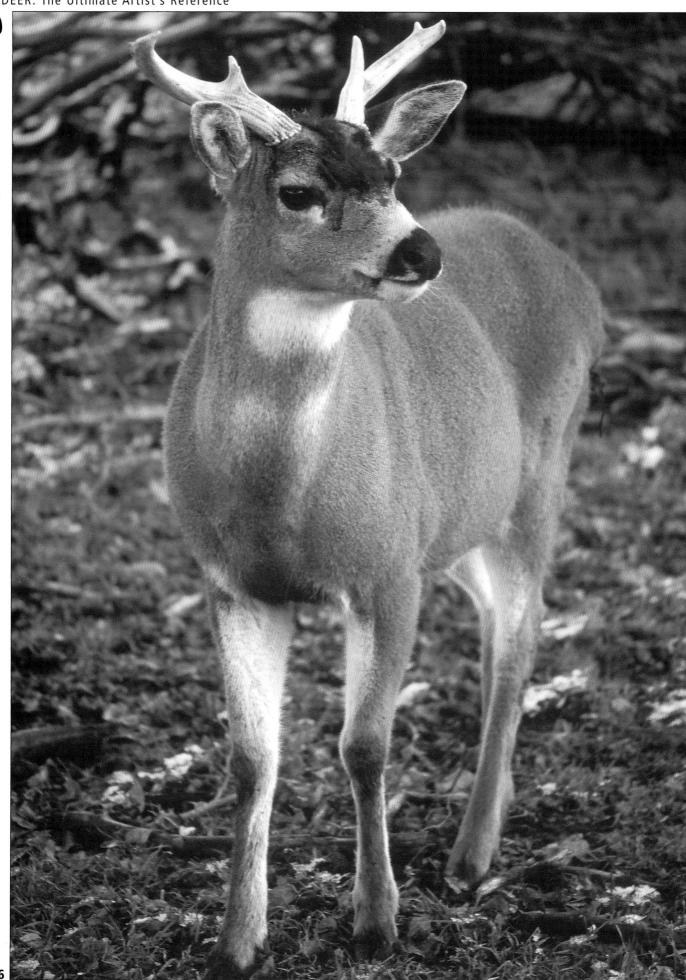

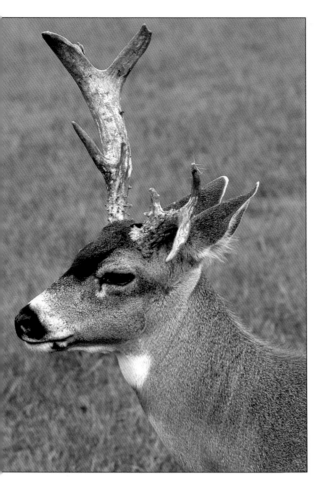

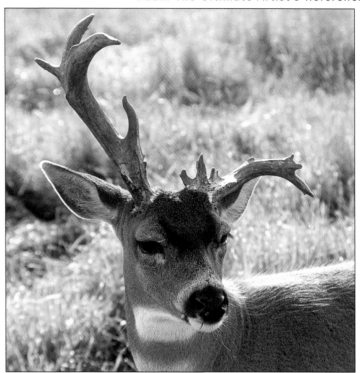

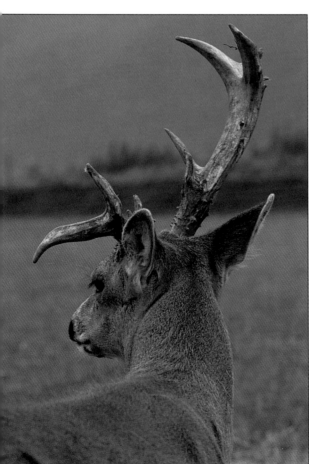

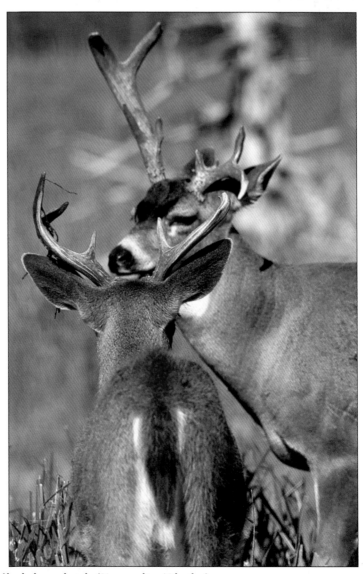

Opposite page: Sitka black-tailed deer, buck (November/Alaska)
Above: Sitka black-tailed deer, bucks (September/Alaska)

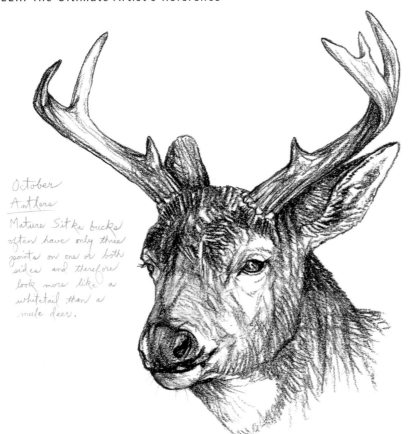

October
Antlers

Mature Sitka bucks
often have only three
points on one or both
sides and therefore
look more like a
whitetail than a
mule deer.

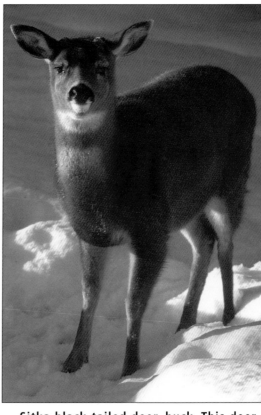

Sitka black-tailed deer, buck. This deer
most likely shed his antlers in January.

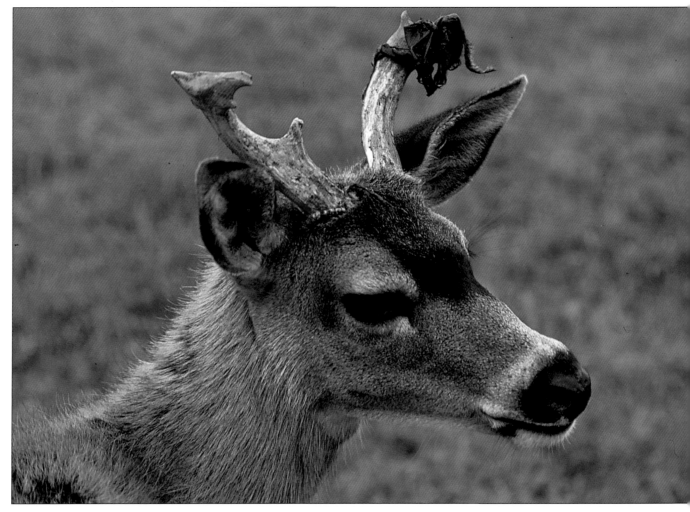

A Sitka black-tailed deer sheds its velvet in September.

- Black-tailed deer fawns usually lose their spots in about ten weeks.

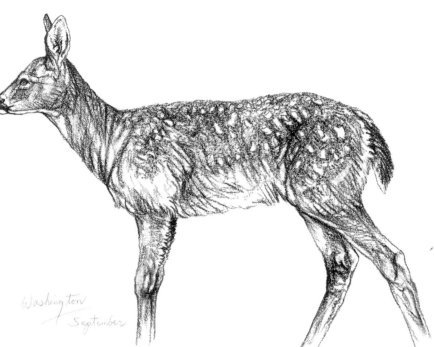

Washington September

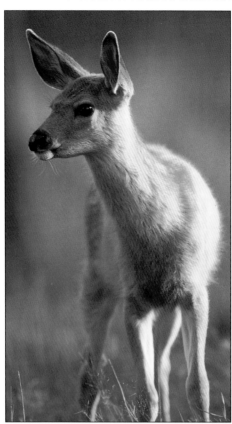

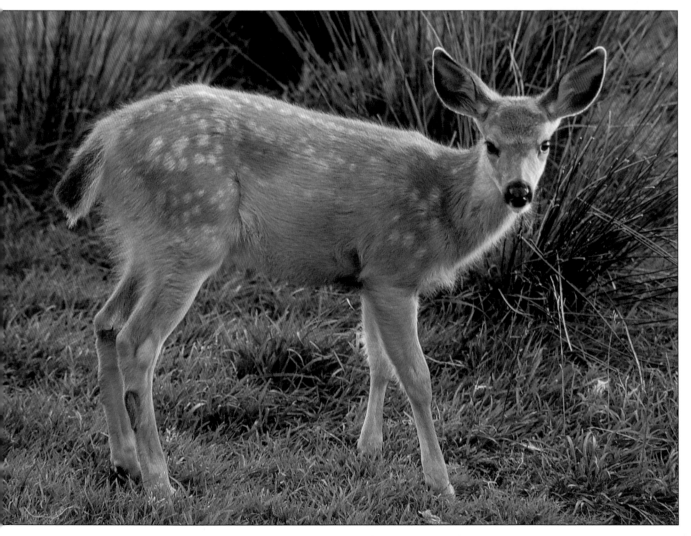

Columbian black-tailed deer, fawns (September)

Black-tailed Deer

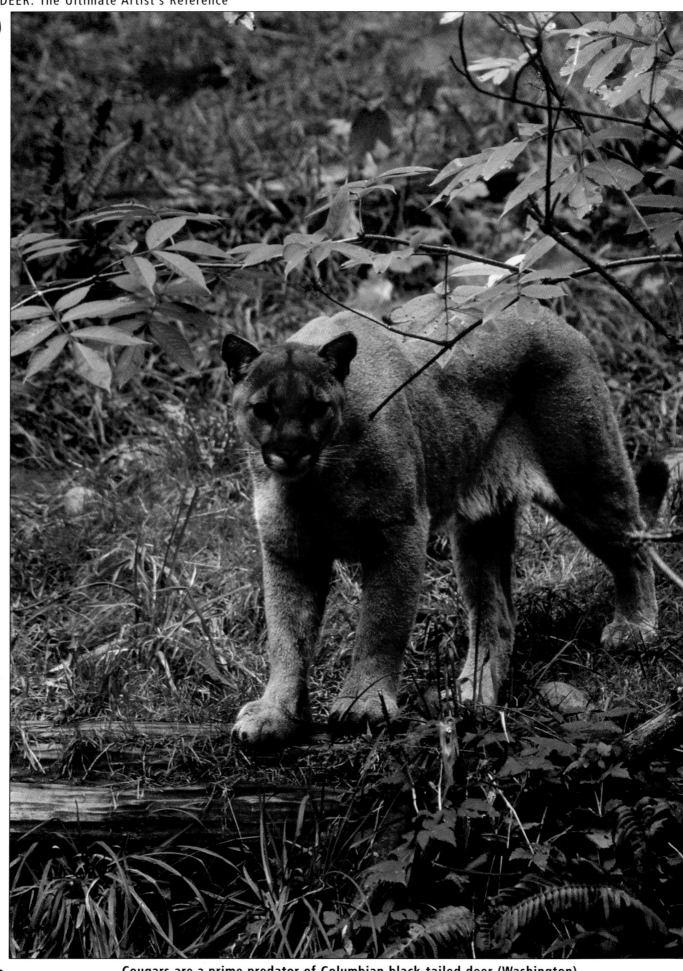

Cougars are a prime predator of Columbian black-tailed deer (Washington).

• There are probably less than two million black tails in North America.

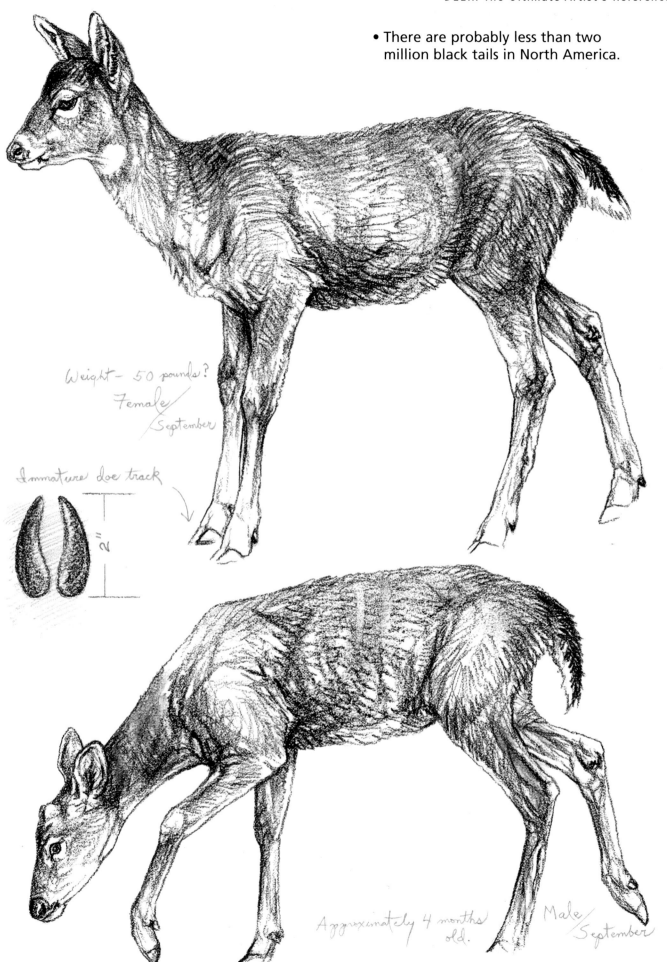

Weight – 50 pounds?
Female/September

Immature doe track

2"

Approximately 4 months old.

Male/September

Black-tailed Deer

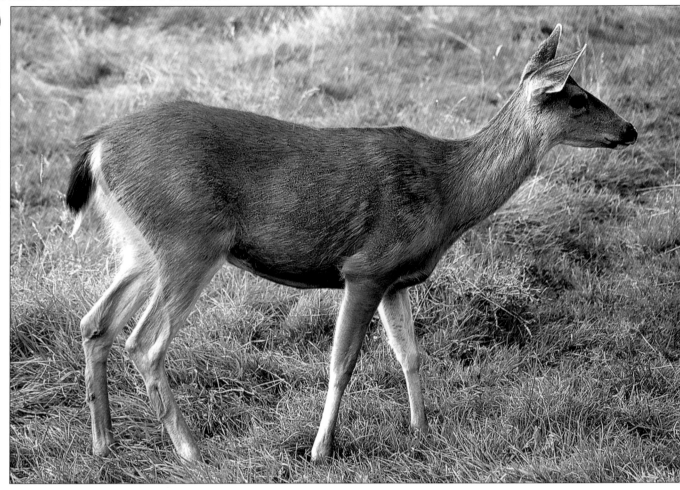

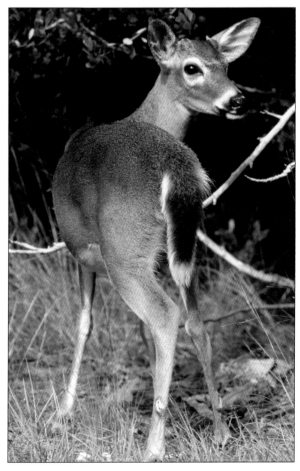

Adult ear:
7 inches long and
5½ inches wide.

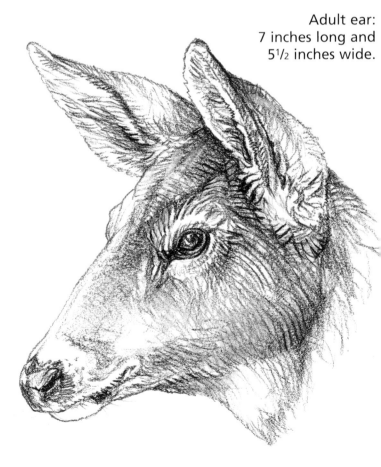

Columbian black-tailed deer, does (September)

• Black-tailed deer have the same bifurcated antler configuration as mule deer. They are, however, smaller in size.

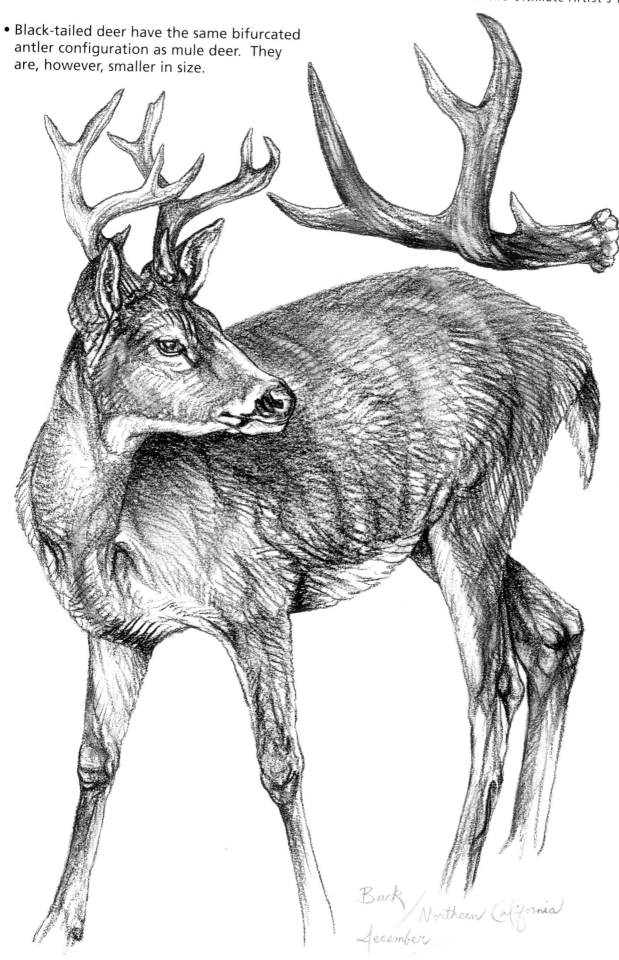

Buck / Northern California
December

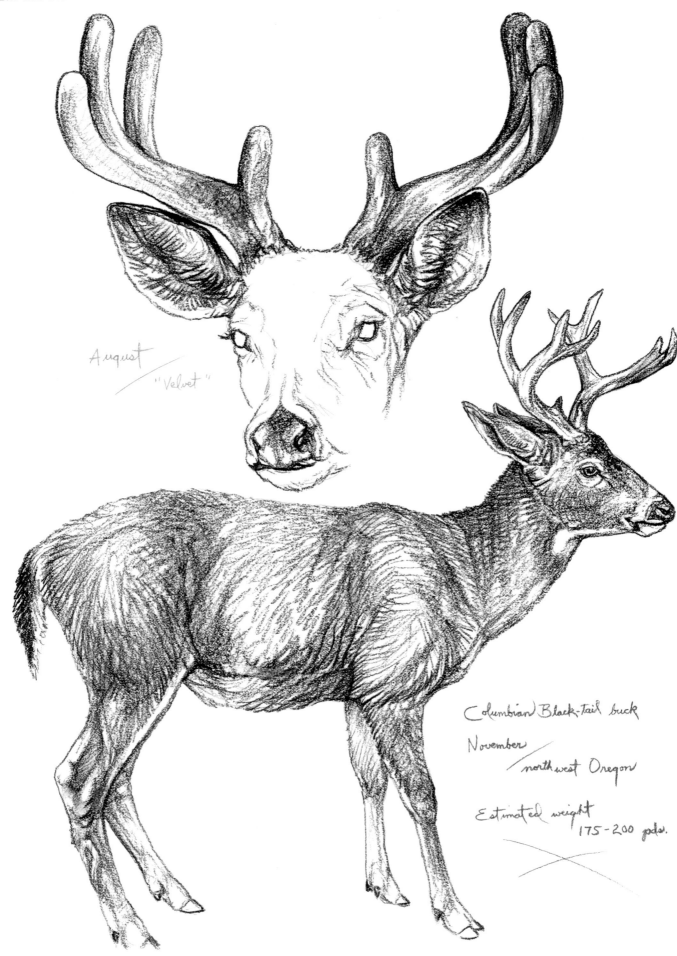

August

"Velvet"

Columbian Black-tail buck

November

northwest Oregon

Estimated weight
175-200 pds.

- Columbian black-tails are longer-legged than the Sitka black-tails. Also, they are slightly heavier. Bucks seldom weigh over 200 pounds. Does weigh 100 to 110 pounds on average.

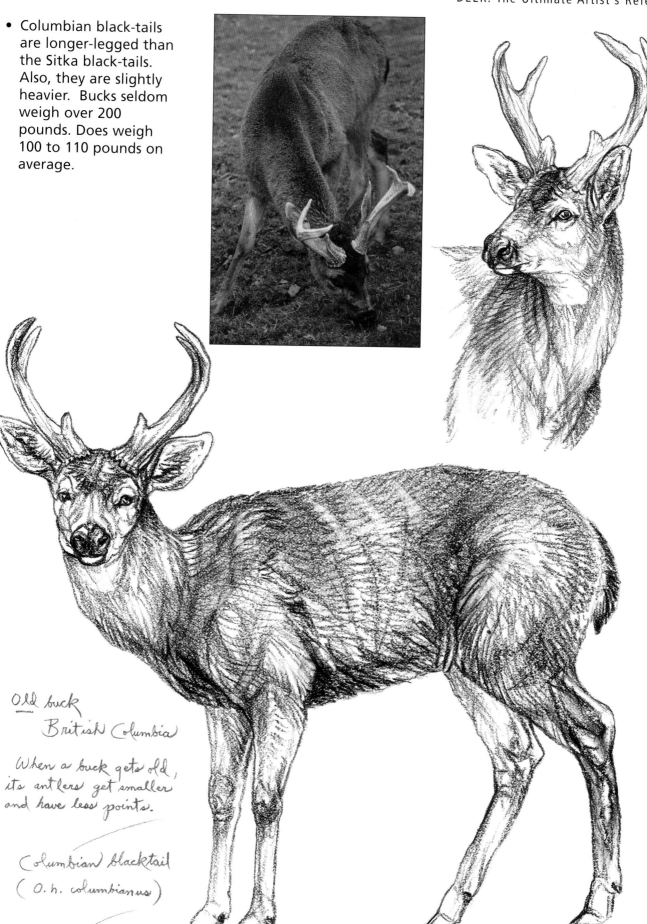

Old buck
British Columbia

When a buck gets old, its antlers get smaller and have less points.

Columbian Blacktail
(O. h. columbianus)

Columbian black-tailed deer, buck (October/British Columbia)

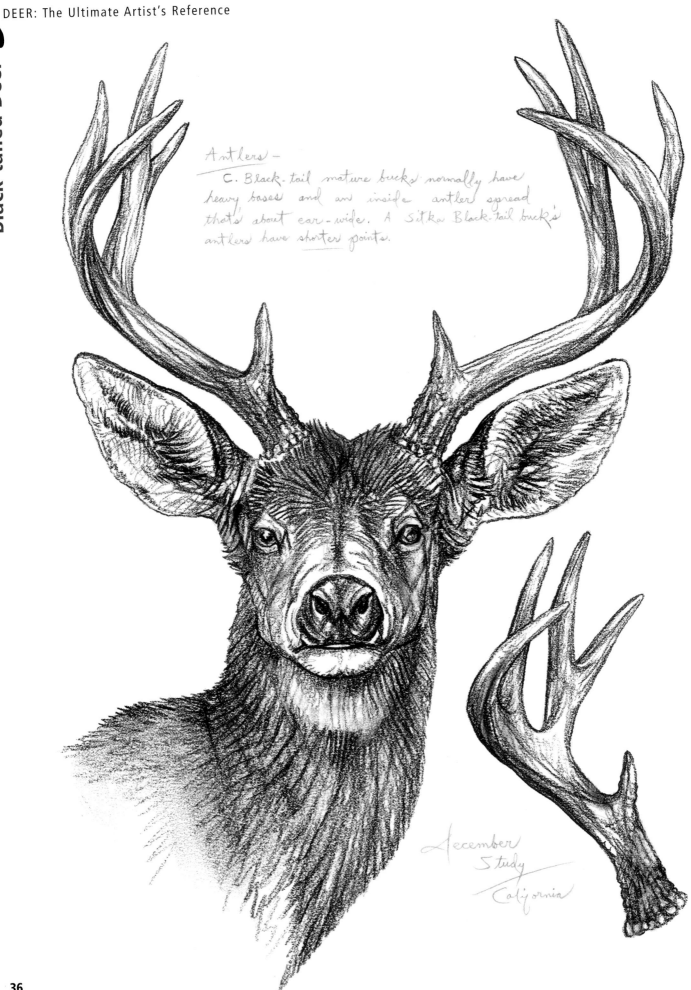

Antlers -

C. Black-tail mature bucks normally have heavy bases and an inside antler spread that's about ear-wide. A Sitka Black-tail buck's antlers have shorter points.

December Study California

Mule Deer

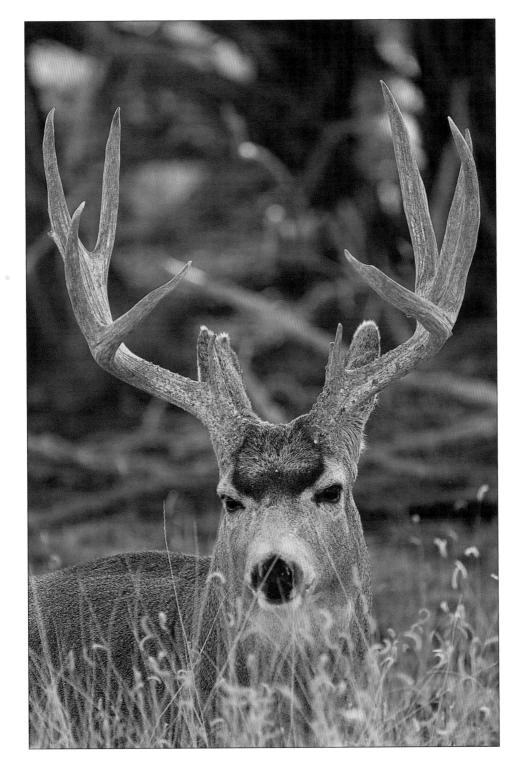

- Fawns grow extremely fast. From their birth weight of six to eight pounds, they will normally double their weight within two weeks. Mule deer fawns are born June to August.

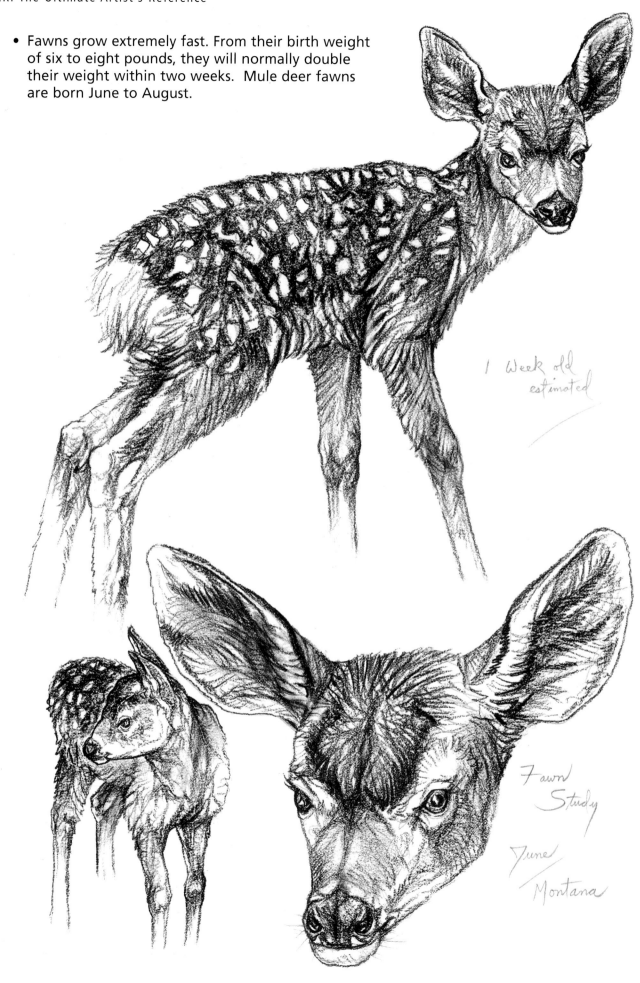

1 week old estimated

Fawn Study

June Montana

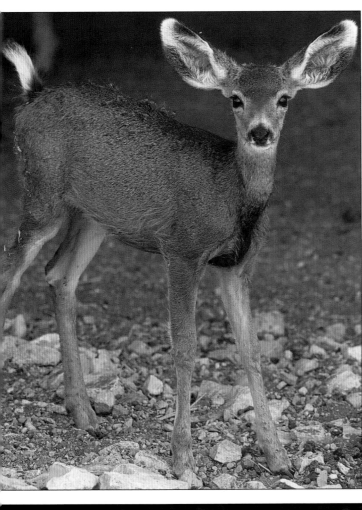
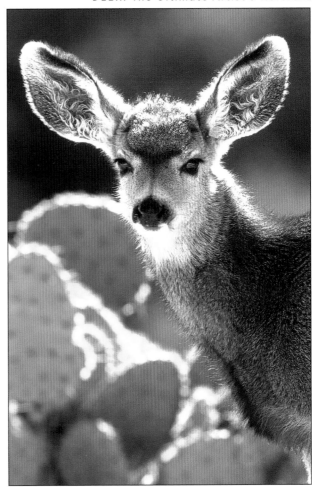
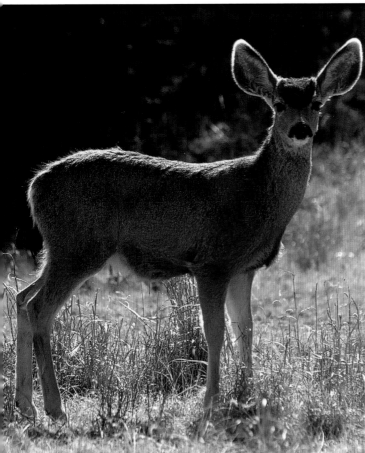
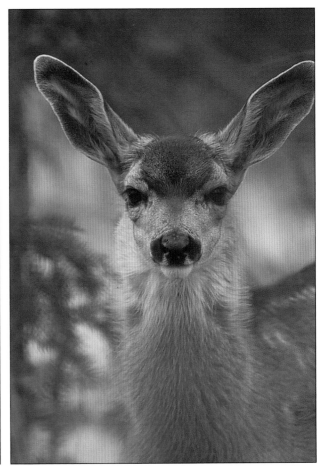

Mule deer, fawns (June, September)

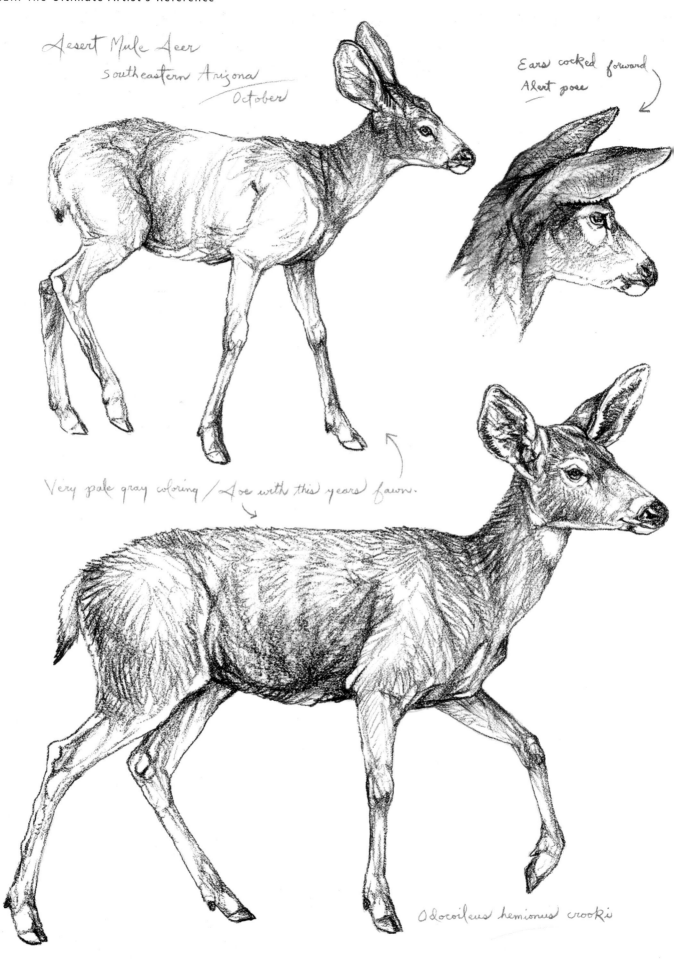

Desert Mule Deer
southeastern Arizona
October

Ears cocked forward
Alert pose

Very pale gray coloring / Doe with this years fawn.

Odocoileus hemionus crooki

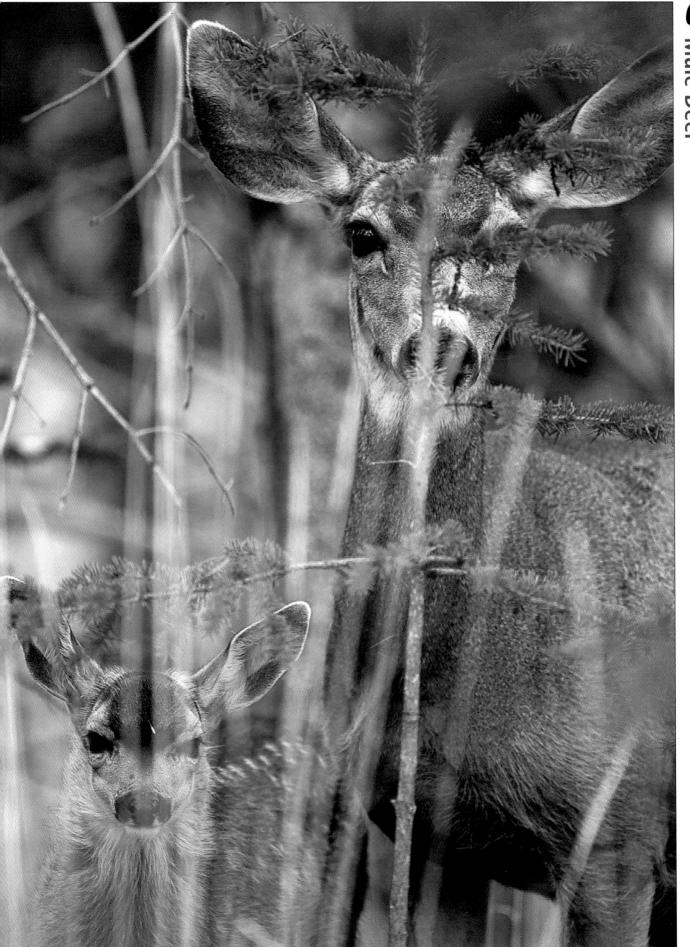

Mule deer, doe and fawn (August/Yukon)

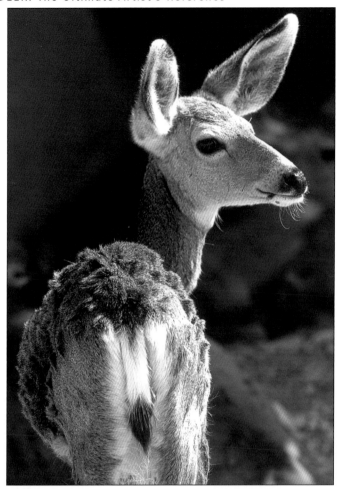

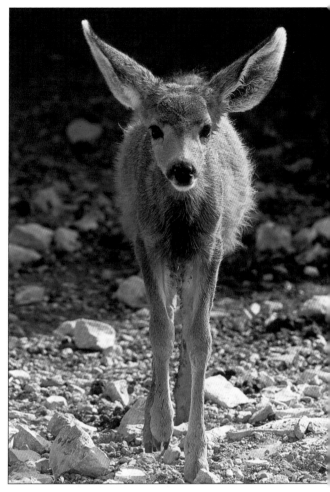

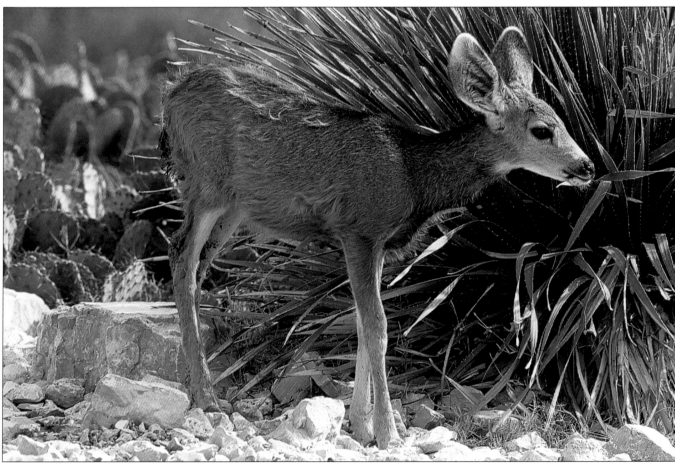

Mule deer, doe and fawn (October/New Mexico)

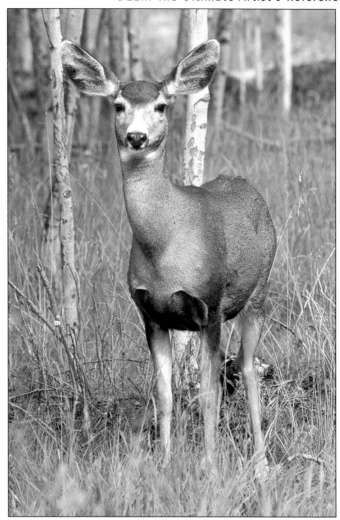

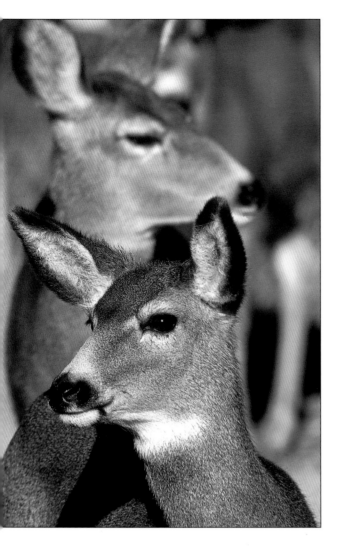

• There are eleven subspecies of the mule deer.

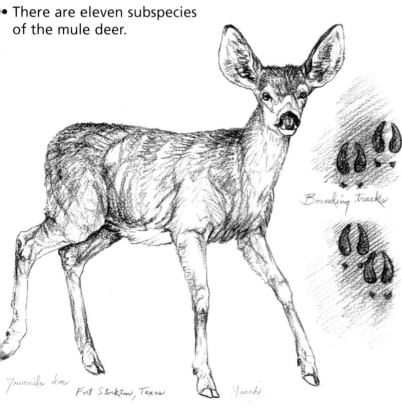

Bounding tracks

Juvenile doe Fort Stockton, Texas March

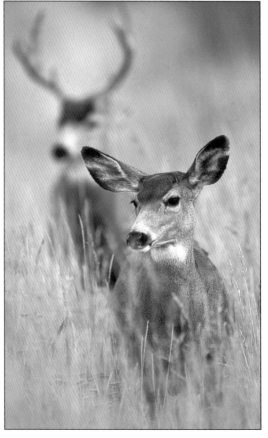

Mule Deer

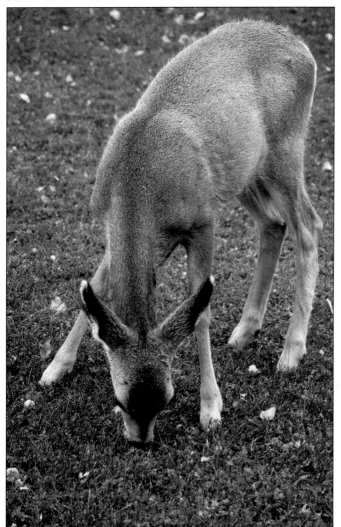

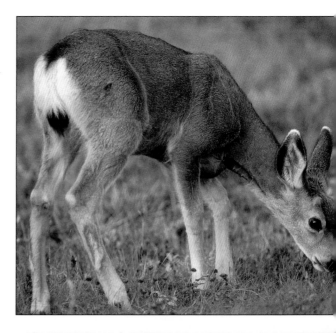

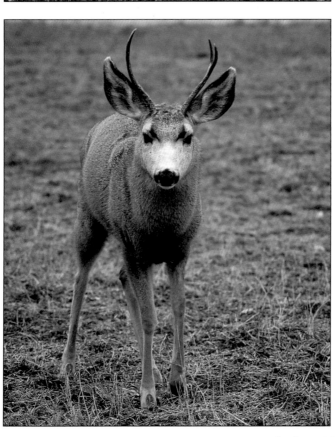

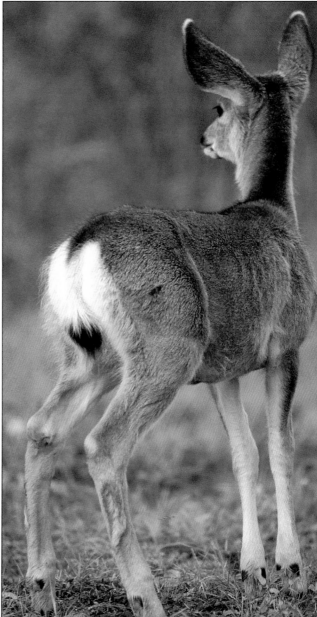

Mule deer (October/Alberta)

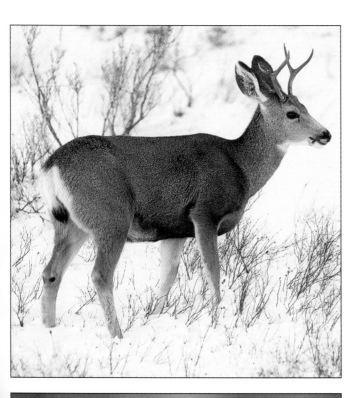

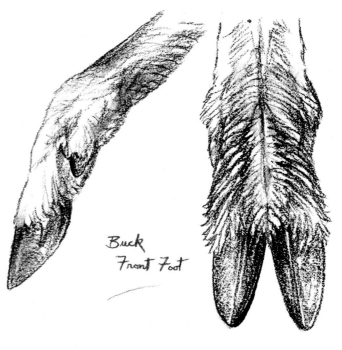

Buck
Front Foot

Though the tail appears to be missing on this doe mule deer, it is just flipped sideways and out of the camera's view.

Mule Deer

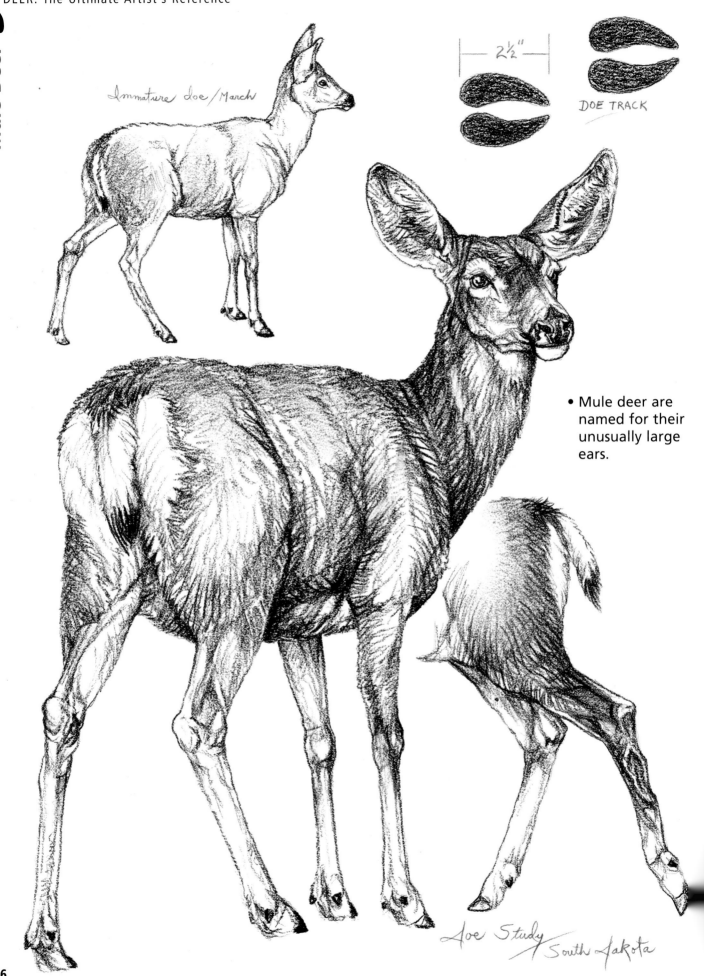

Immature doe/March

2 ½"

DOE TRACK

• Mule deer are named for their unusually large ears.

Doe Study South Dakota

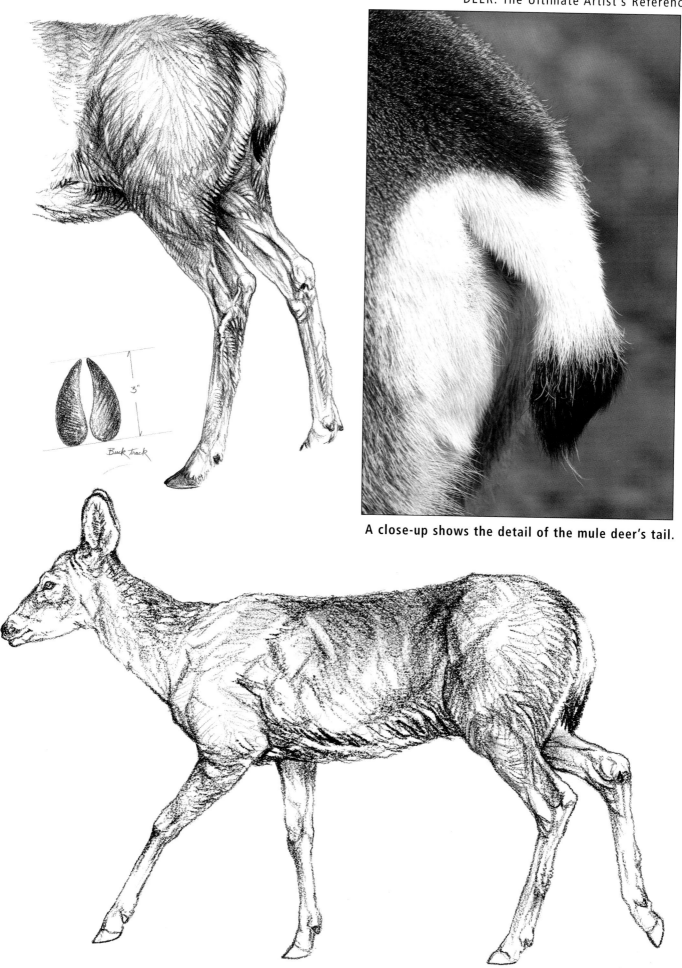

Buck Track

3"

A close-up shows the detail of the mule deer's tail.

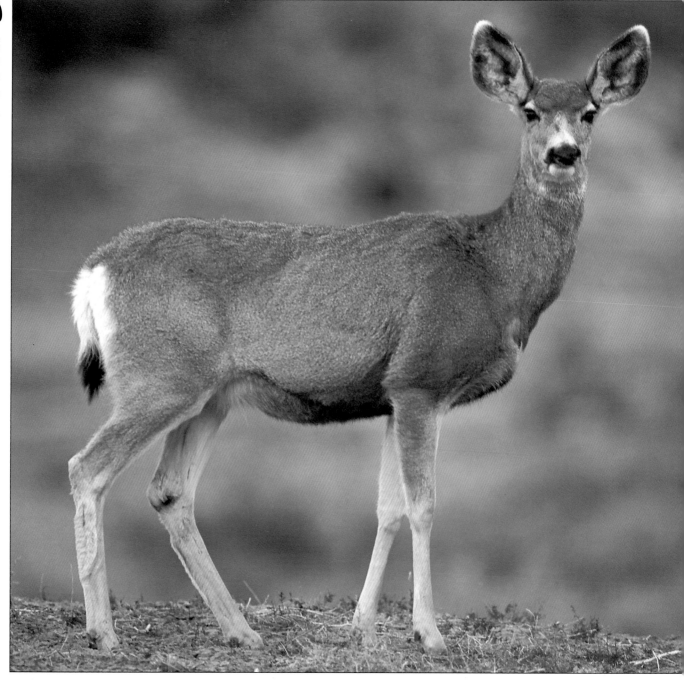

Mule deer, doe (September/Montana)

Deer are commonly seen in or around towns and cities across North America. The plants, trees and grasses planted by humans often draw deer from the surrounding wild areas where food may not be as plentiful as in areas of human habitation. Their presence then draws predators such as coyotes, bears and mountain lions into these same areas, putting people in increased danger. Also, despite deer's gentle-looking appearance, they too can be extremely dangerous. Bucks, for example, are usually at their meanest just prior to their breeding season. Once the does have become receptive, it seems the belligerent bucks vent their anger more at other competing bucks than at humans.

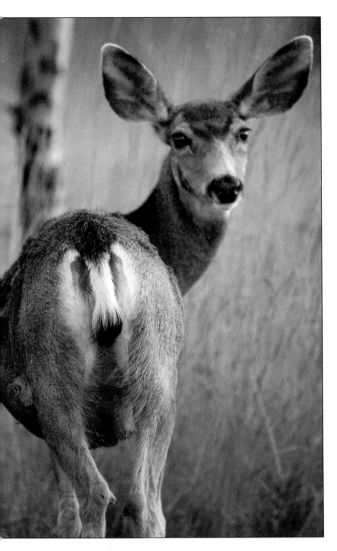

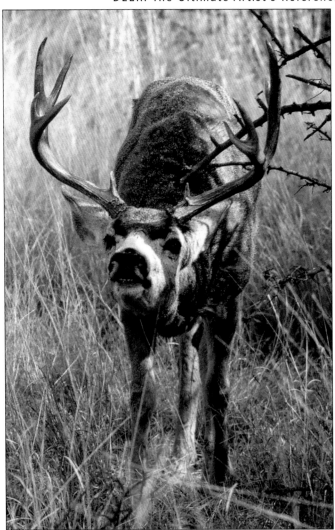

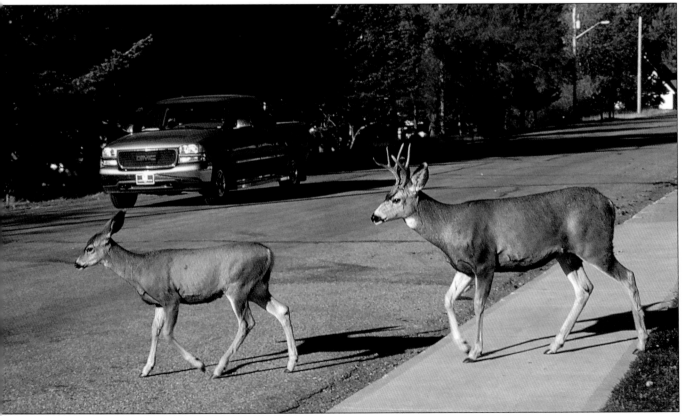

Mule deer (Bottom photo: September/Waterton, Alberta)

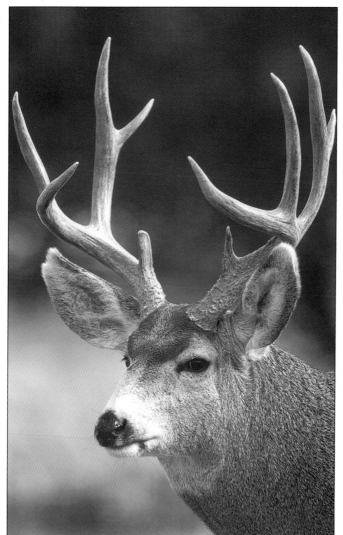
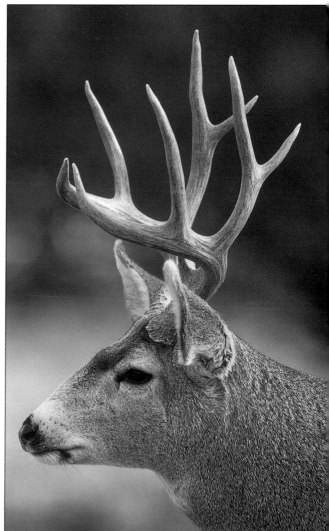

Mule deer, bucks (October/New Mexico)

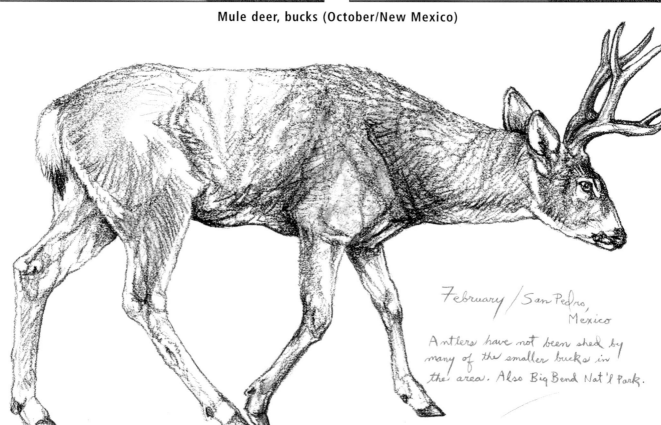

February / San Pedro, Mexico

Antlers have not been shed by many of the smaller bucks in the area. Also Big Bend Nat'l Park.

Shed antler
Utah / January

September

42-44"

• Brow tines are seldom longer than 3 inches on mule deer antlers.

Rocky Mountain Mule Deer
(Odocoileus hemionus hemionus)
The largest mule deer subspecies.
New Mexico / December

Winter coat

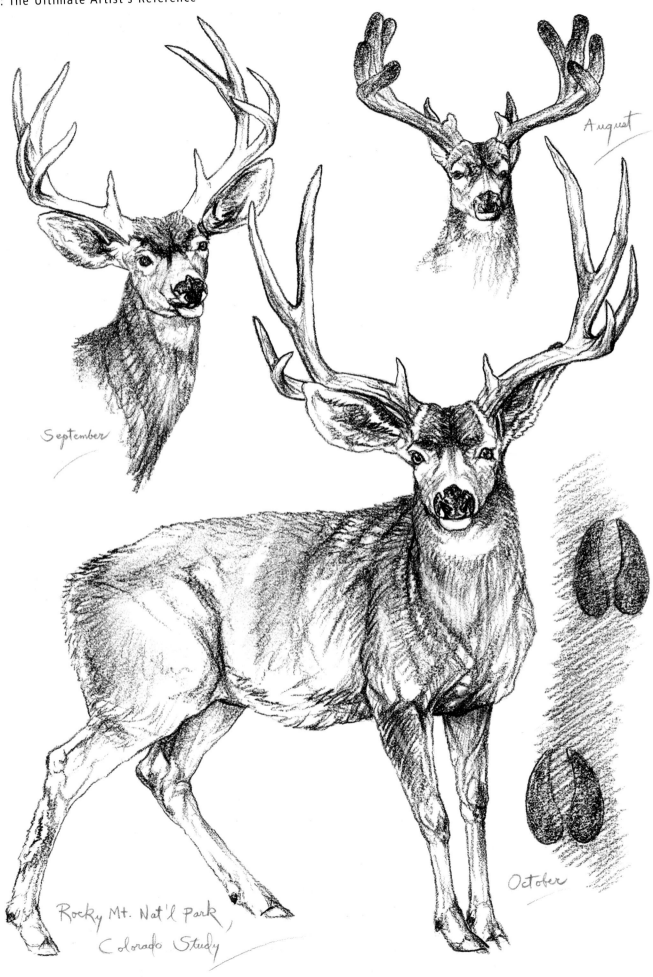

August

September

October

Rocky Mt. Nat'l Park,
Colorado Study

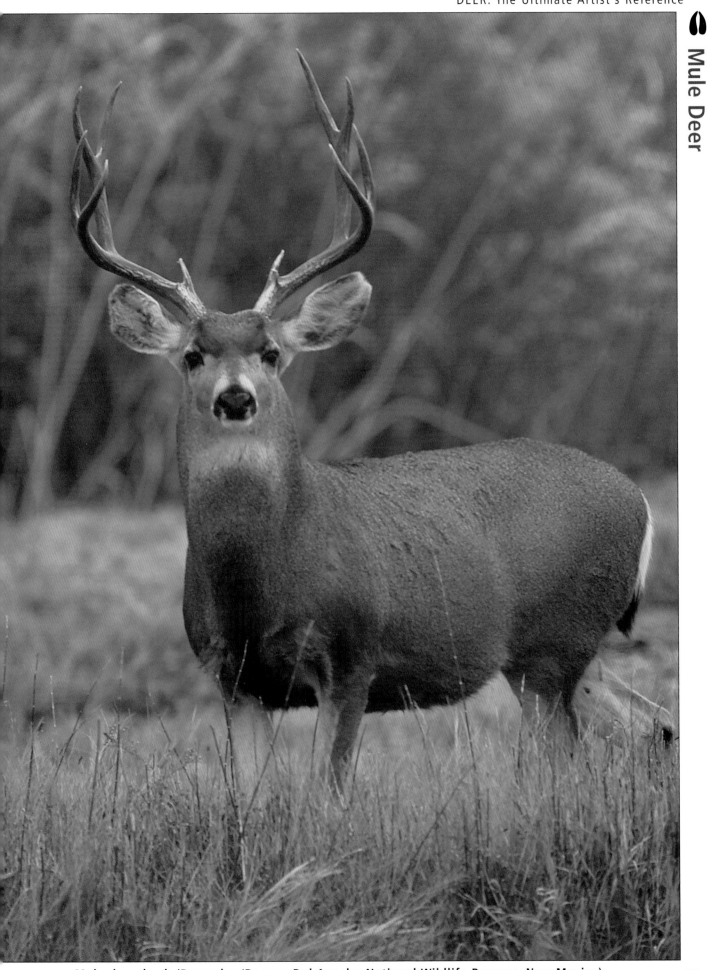

Mule deer, buck (December/Bosque Del Apache National Wildlife Reserve, New Mexico)

Mule Deer

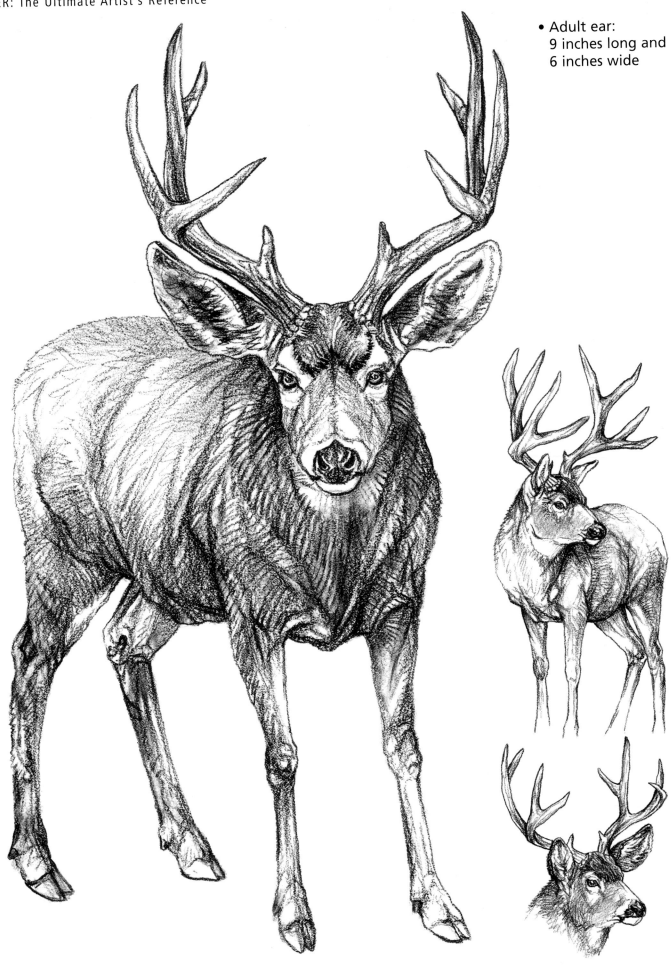

- Adult ear:
 9 inches long and
 6 inches wide

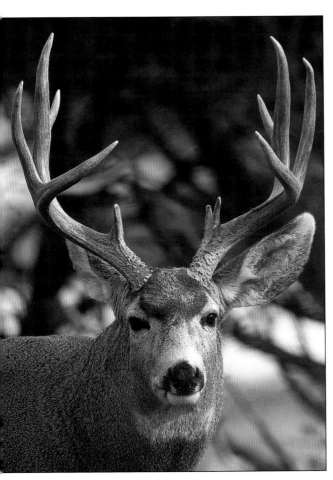
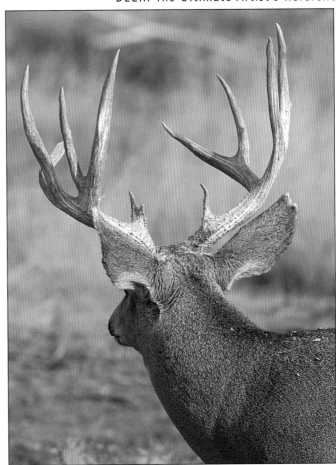

Mule deer, bucks (October/New Mexico)

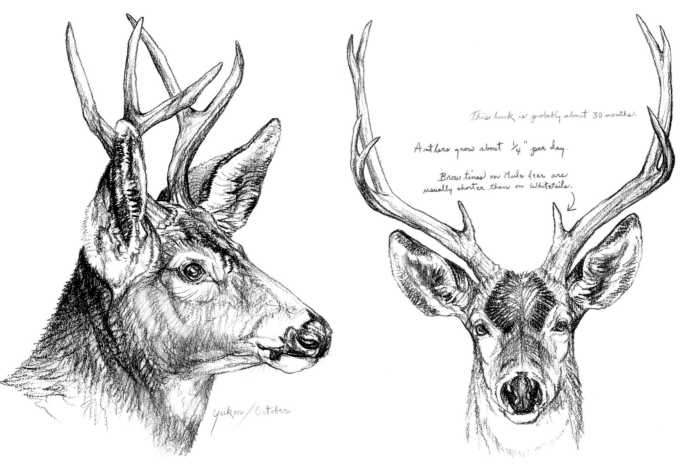

yukon/October

This buck is probably about 30 months.

Antlers grow about 1/4" per day.

Brow tines on Mule deer are usually shorter than on Whitetails.

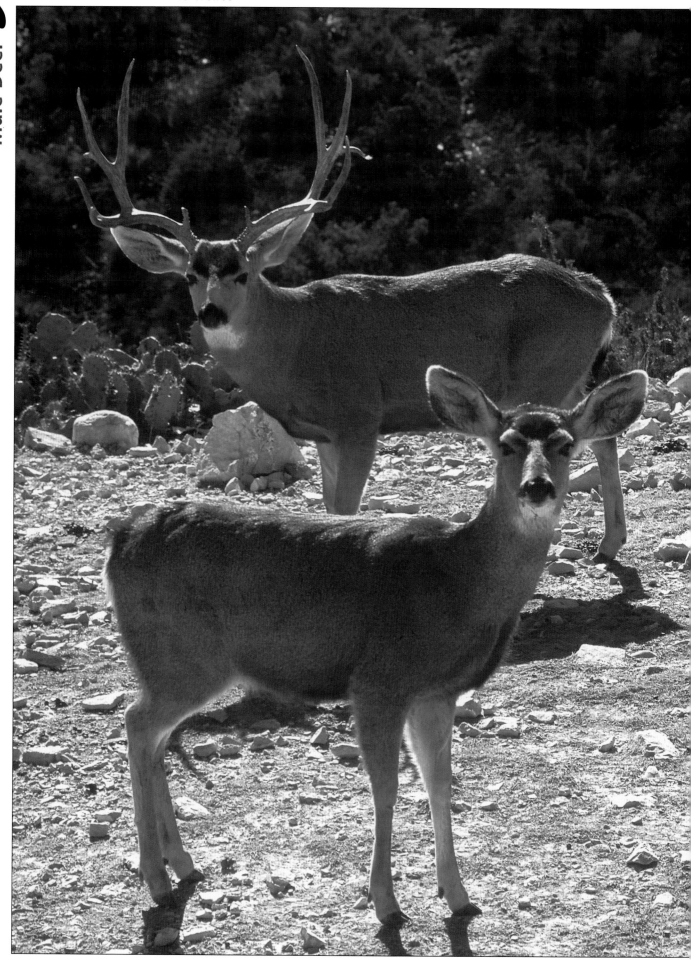

Mule deer, buck and doe (January/New Mexico)

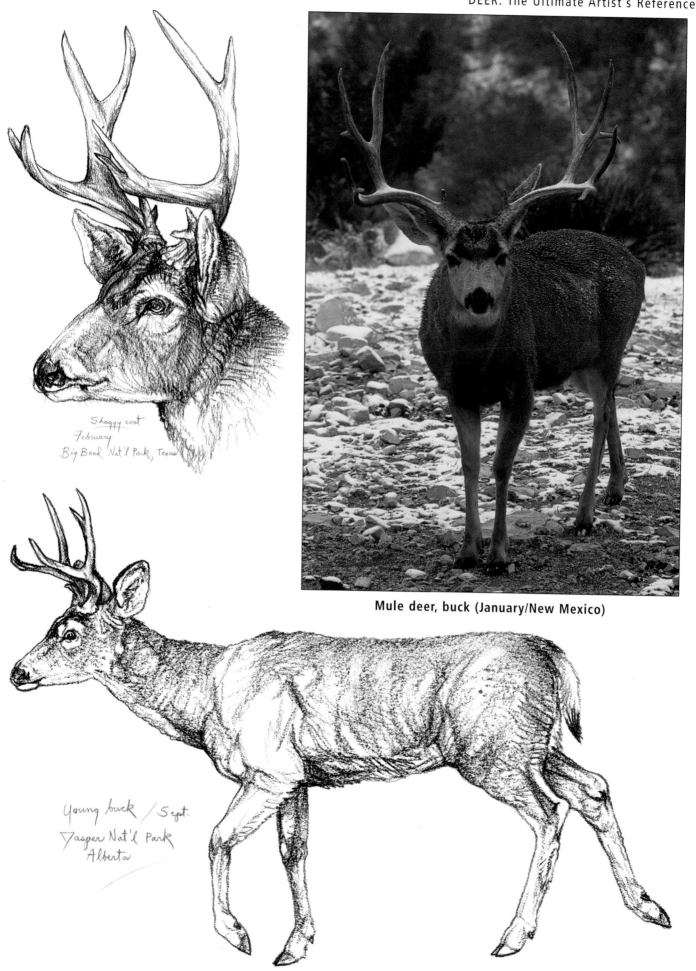

Shaggy coat
February
Big Bend Nat'l Park, Texas

Mule deer, buck (January/New Mexico)

Young buck / Sept.
Jasper Nat'l Park
Alberta

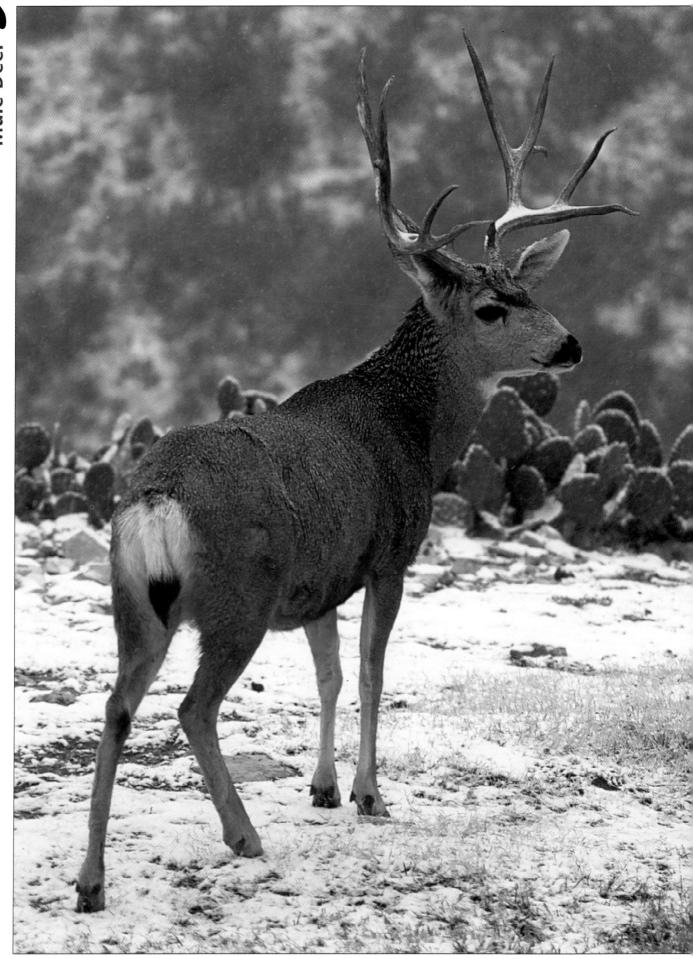

Mule deer, buck (February)

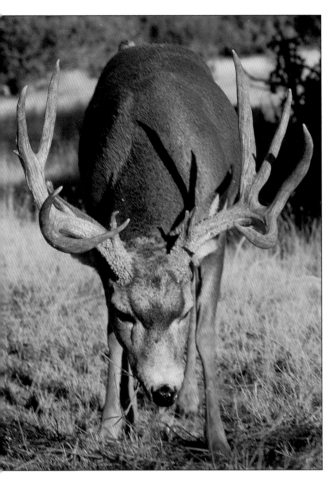
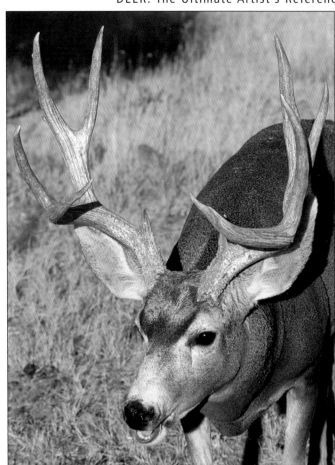

Mule deer buck (October)

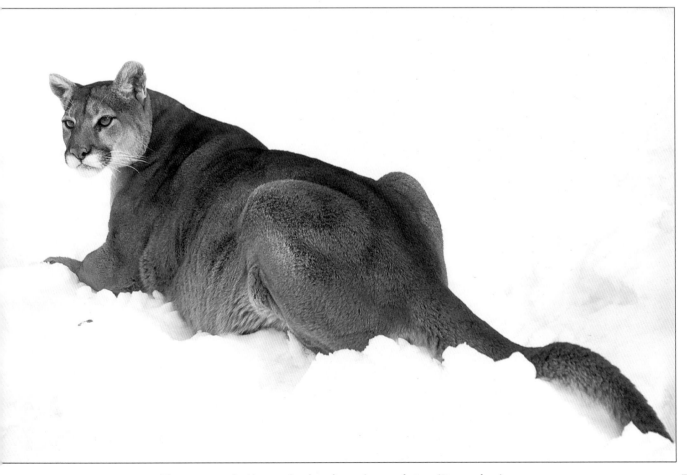

The cougar is the mule deer's main predator (December).

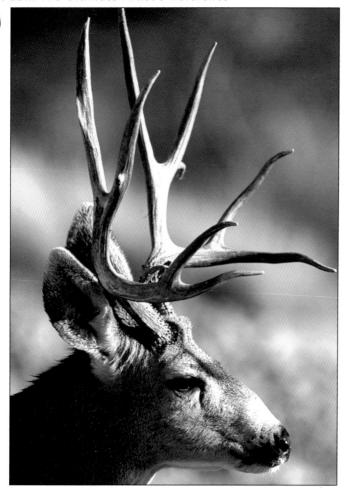

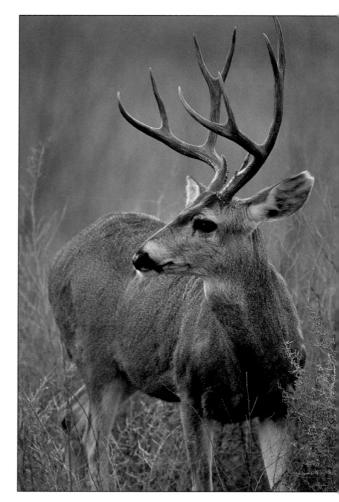

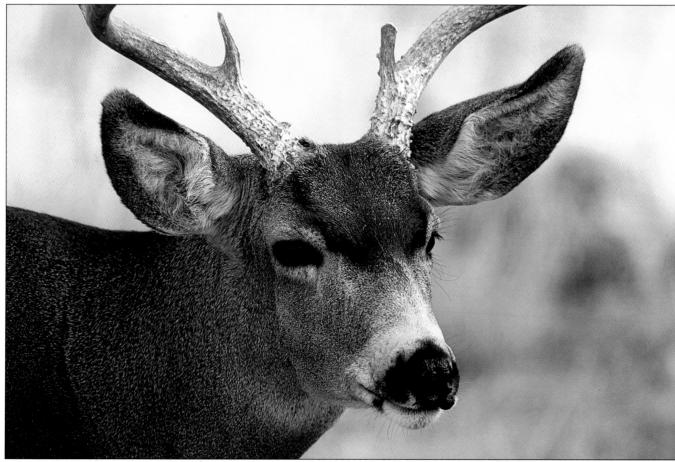

Mule deer, bucks (Autumn)

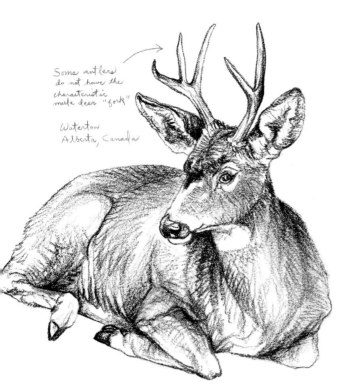

Some antlers do not have the characteristic mule deer "fork"

Waterton Alberta, Canada

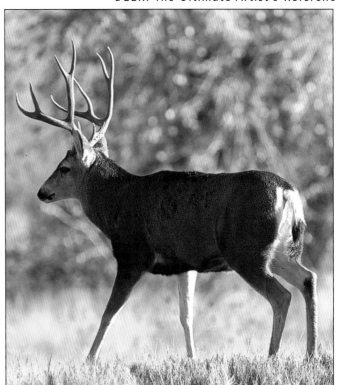

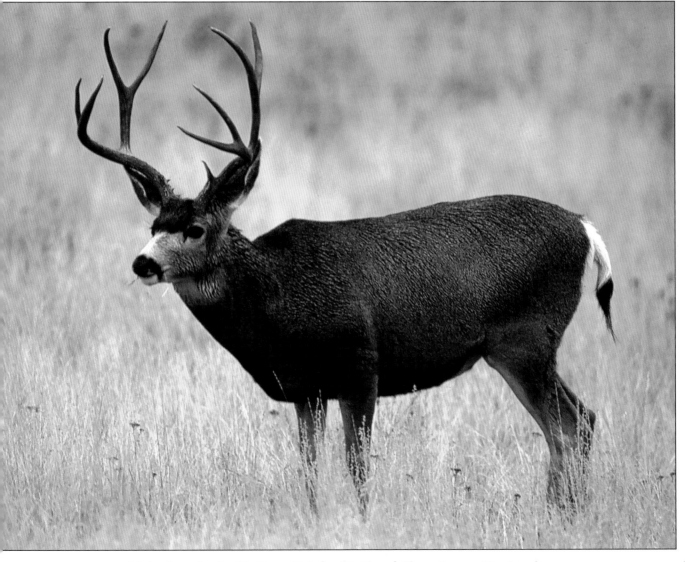

Mule deer, bucks (Bottom: October/National Bison Range, Montana)

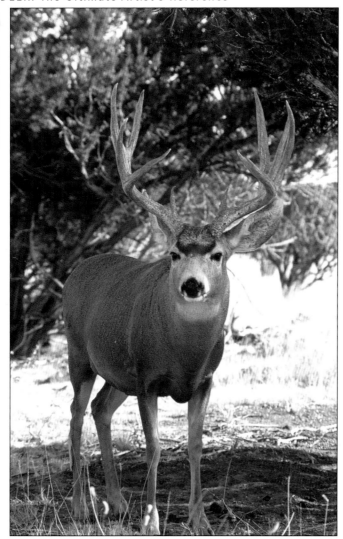

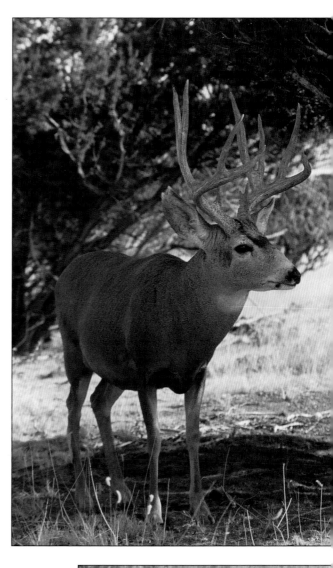

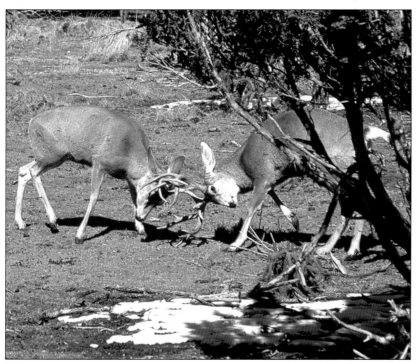

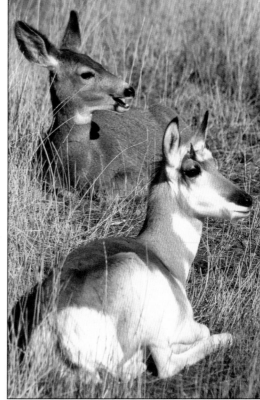

Mule deer. Pronghorns and mule deer (bottom right) often occupy the same range.

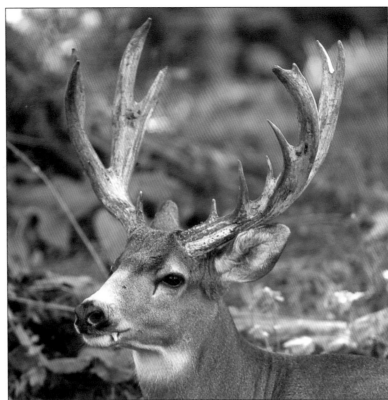

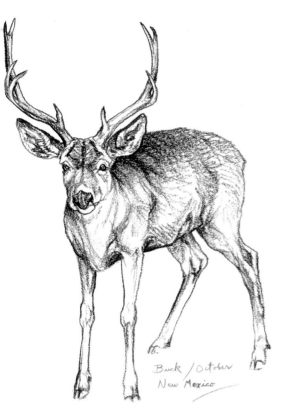

Buck / October
New Mexico

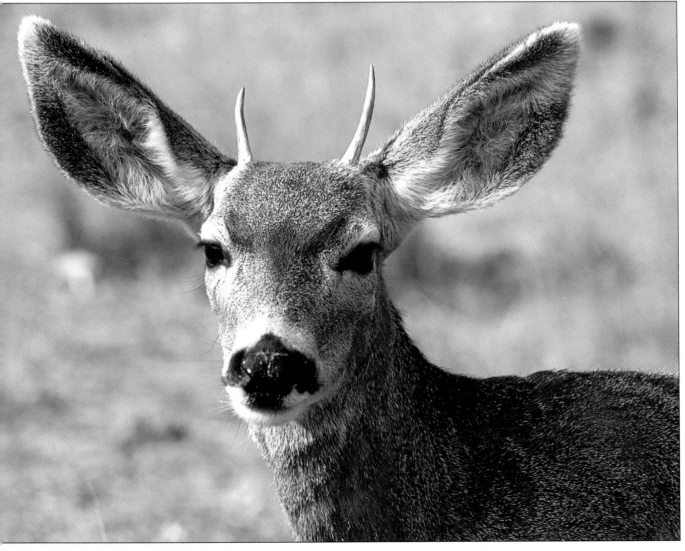

Mule deer, bucks (Bottom: Spike buck, Montana)

Mule Deer

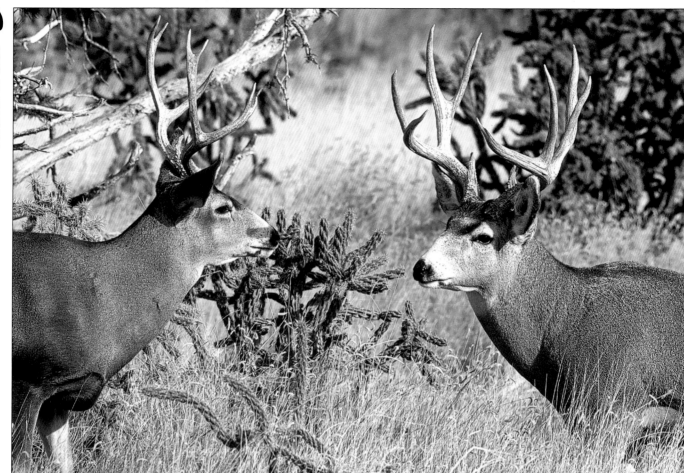

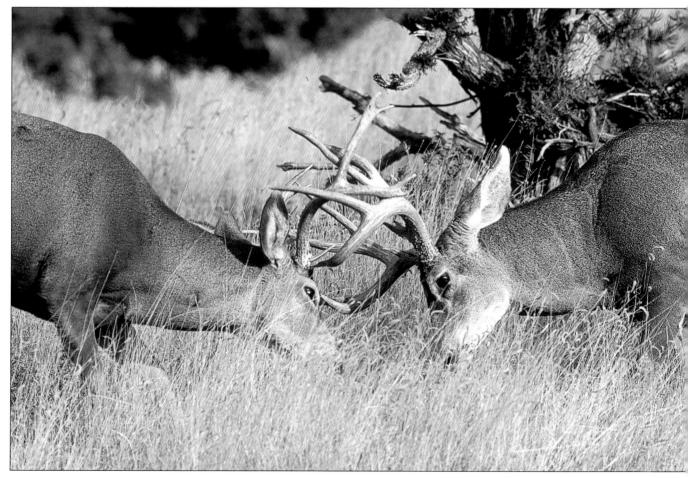

Mule deer bucks sparring during the autumn rut (October/New Mexico).

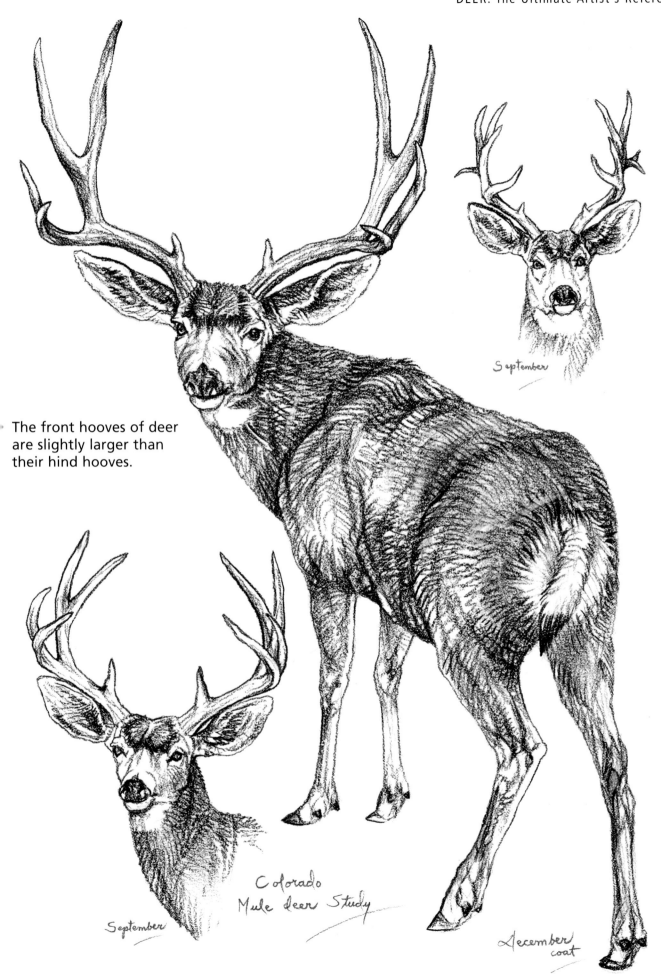

The front hooves of deer are slightly larger than their hind hooves.

September

Colorado
Mule deer Study

September

December
coat

Mule Deer

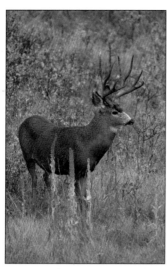
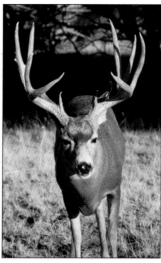
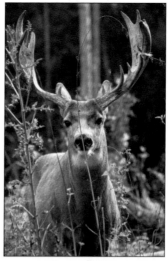
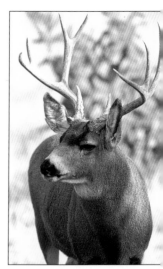

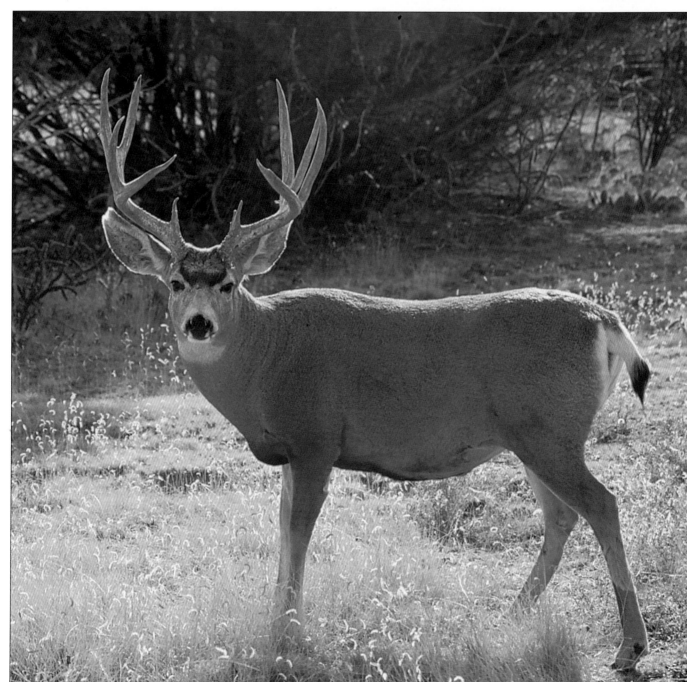

Mule deer, bucks

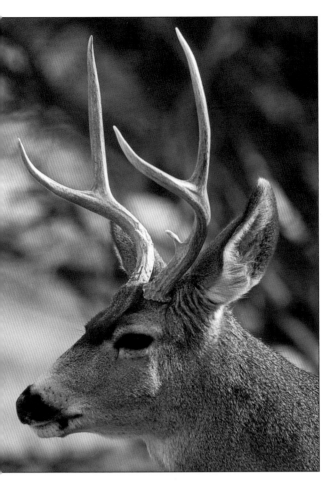
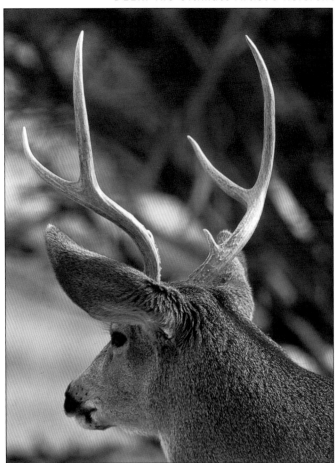

Mule deer, bucks (October/Idaho)

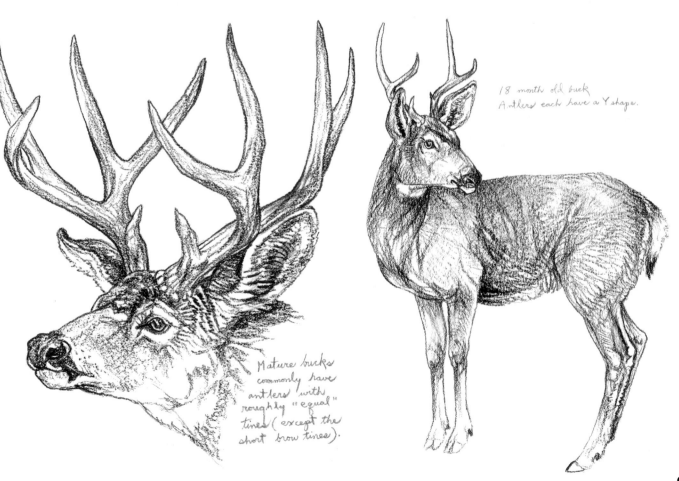

18 month old buck
Antlers each have a Y shape.

Mature bucks commonly have antlers with roughly "equal" tines (except the short brow tines).

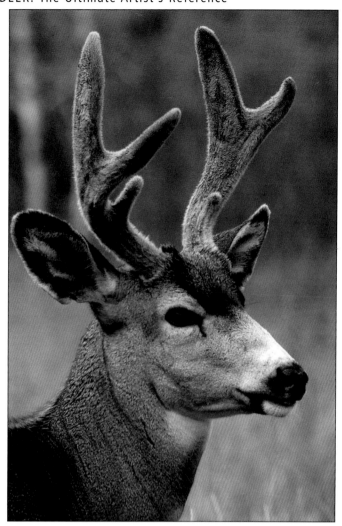

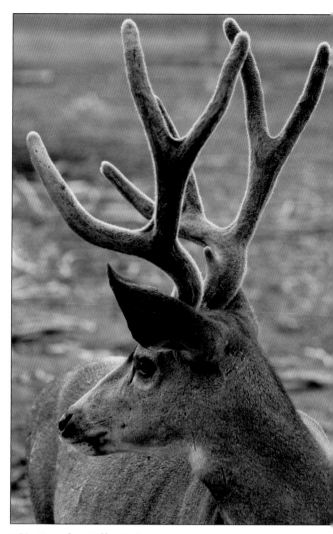

Mule deer, bucks in velvet (September/Alberta)

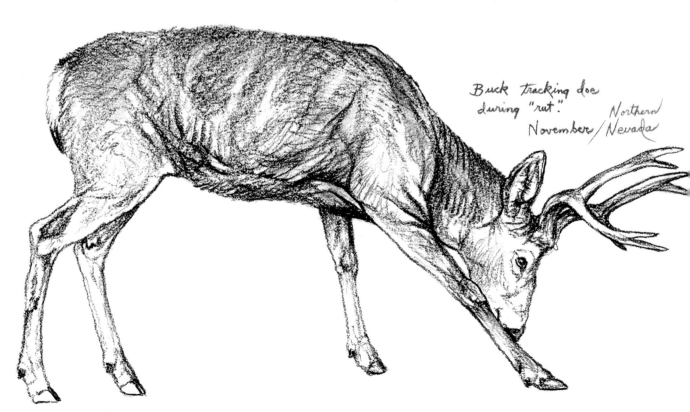

Buck tracking doe
during "rut."
November/ Northern
Nevada

Antlers

Antlers are found on the Cervidea family: moose, elk, caribou and deer. They are unlike horns in that the male members grow and shed antlers yearly. Antlers are true bones but lack the marrow of other mammal bones. The size and shape of antlers depend on food, health, age and heredity.

Antlers begin to grow in late March in response to the cycle of light and dark called photoperiodism. This cycle is determined by a deer's latitude, and so antler growth will vary from north to south.

Antlers grow for about 100 days. Antlers are not hardened until they reach their full size beneath the velvet skin that has nourished them. The internal blood flow is then slowly reduced until the velvet dries and is then peeled off by rubbing it against trees and brush. During the following months—and with increased levels of testosterone, which causes bucks' necks to swell—they will seek out receptive does to mate and also do battle with rival bucks. After the rut, the dominant bucks will normally shed their antlers first, and most bucks will have shed their antlers by February or March.

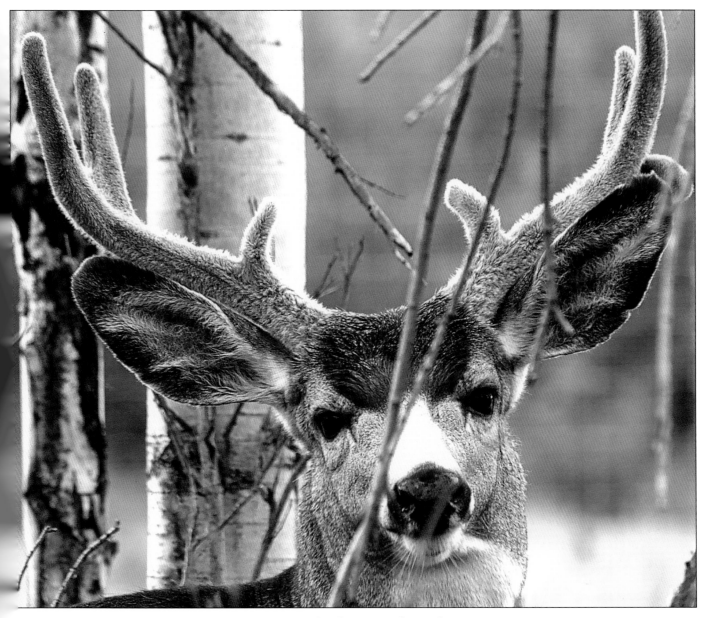

Mule deer, buck (September/Yukon)

Mule Deer

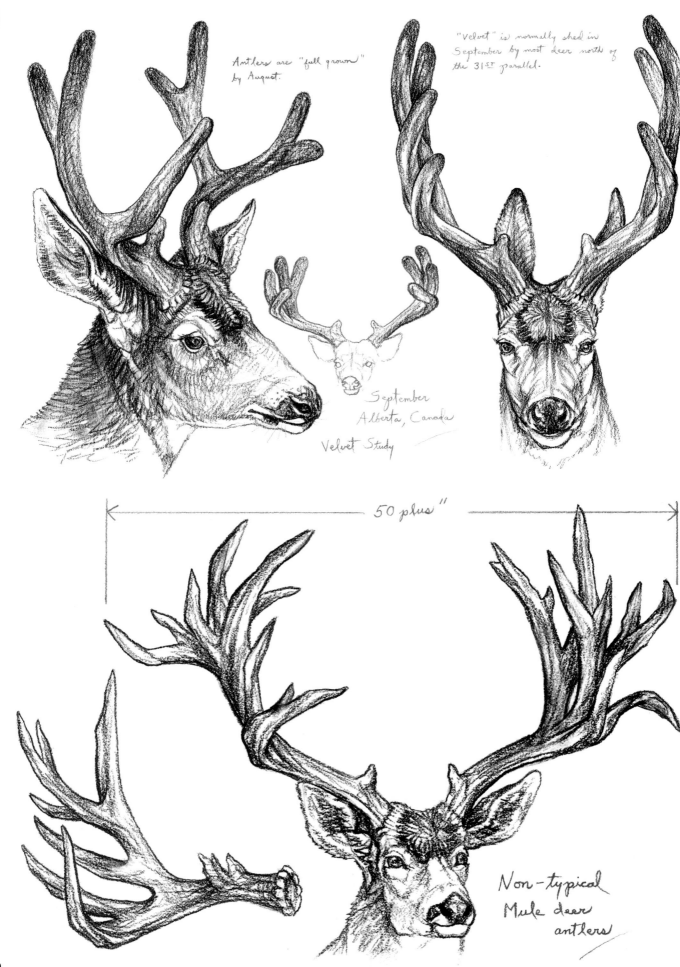

Antlers are "full grown" by August.

"Velvet" is normally shed in September by most deer north of the 31ST parallel.

September
Alberta, Canada

Velvet Study

50 plus "

Non-typical Mule deer antlers

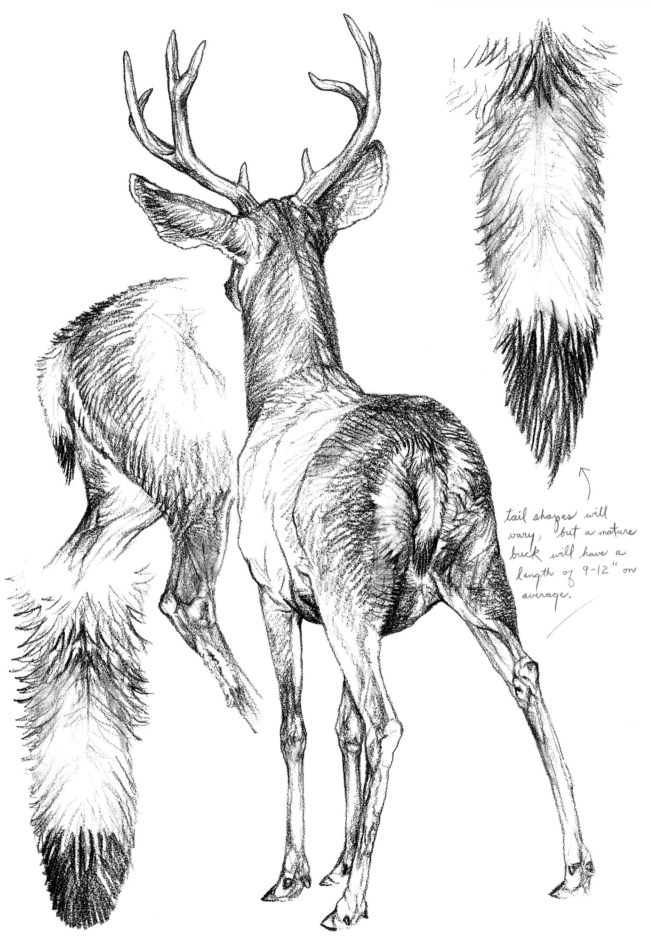

tail shapes will vary, but a mature buck will have a length of 9-12" on average.

The mule deer is much more of a "wilderness" species than is the white-tailed deer.
It is estimated that there are about four million mule deer in North America.

White-tailed Deer

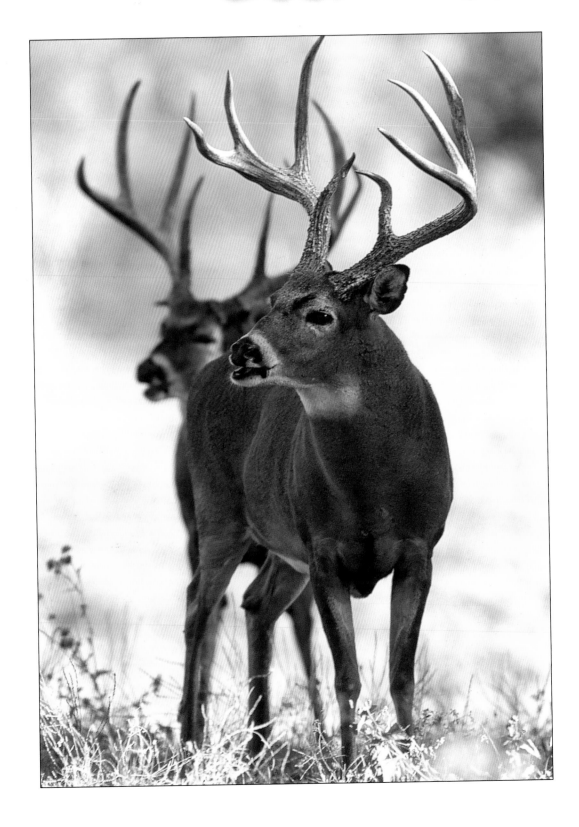

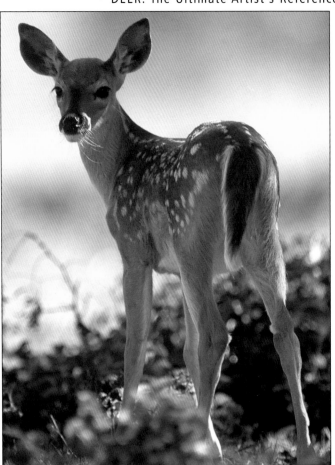

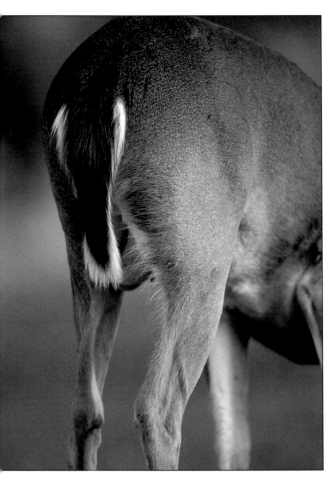

White-tailed deer (Left: doe. Right: fawn, August)

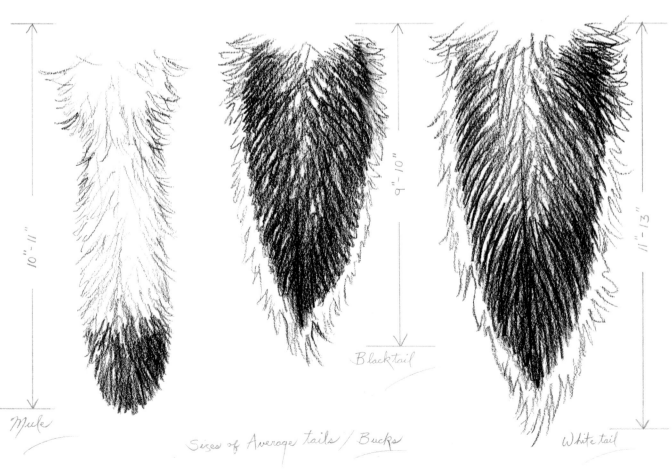

10"–11"

Mule

Sizes of Average tails / Bucks

9"–10"

Blacktail

11"–13"

White tail

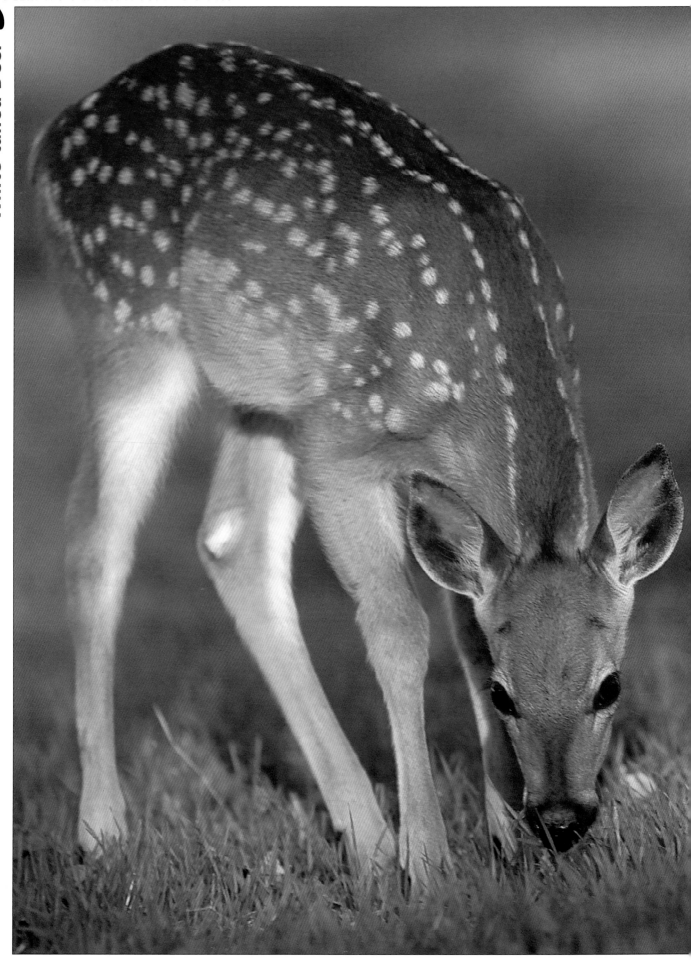

White-tailed deer, fawn (September/Texas)

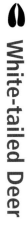

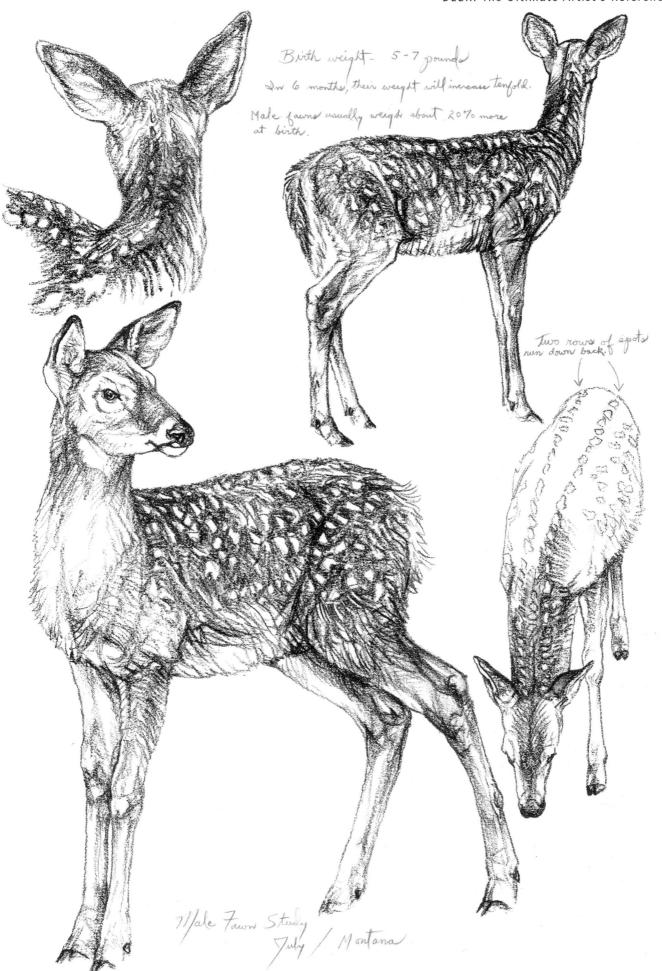

Birth weight - 5-7 pounds

In 6 months, their weight will increase tenfold.

Male fawns usually weigh about 20% more at birth.

Two rows of spots run down back.

Male Fawn Study
July / Montana

White-tailed Deer

7 fawn track

1½"

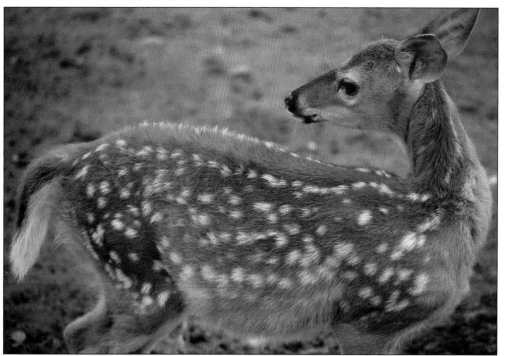

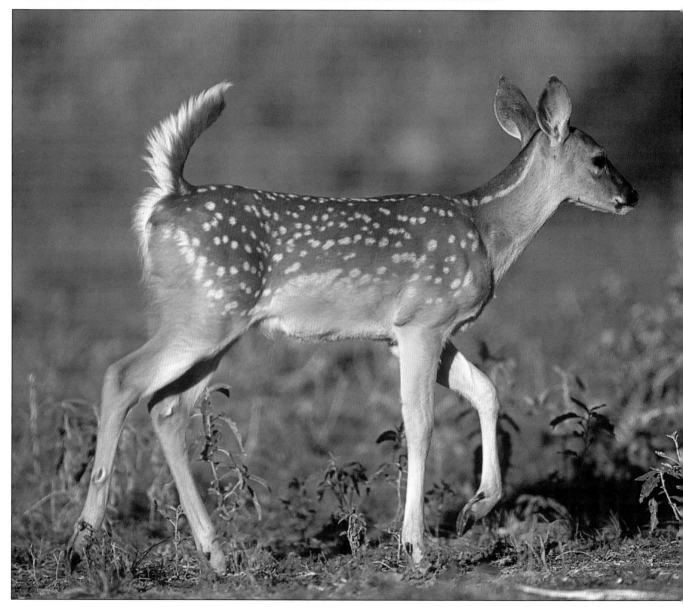

White-tailed deer, fawns

• It is a common belief that very young fawns have no detectable odor and hence cannot be detected by predators if they stay motionless in cover.

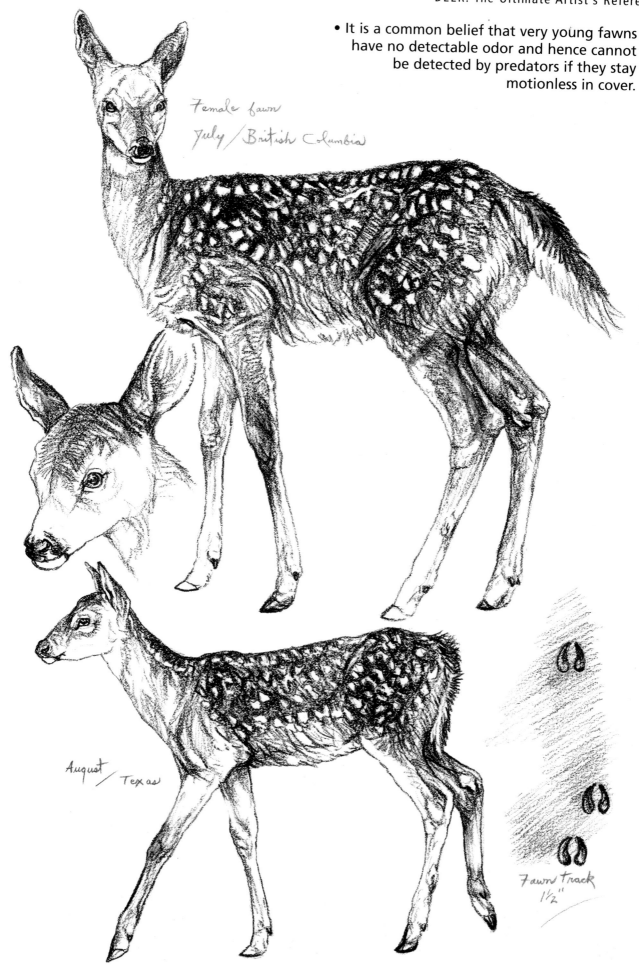

Female fawn
July / British Columbia

August / Texas

Fawn Track
1½"

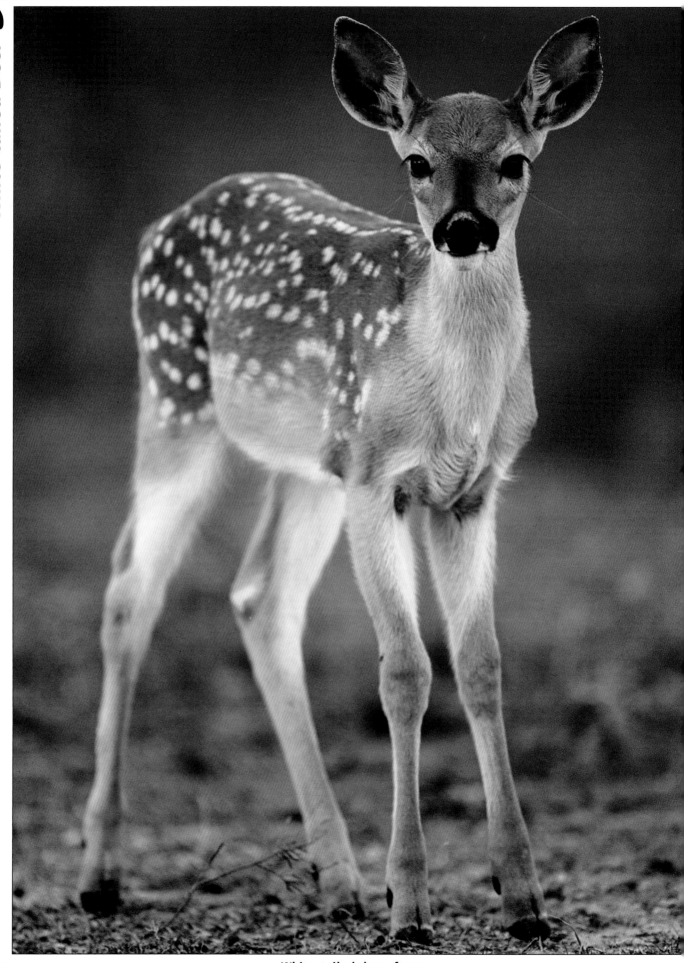

White-tailed deer, fawn

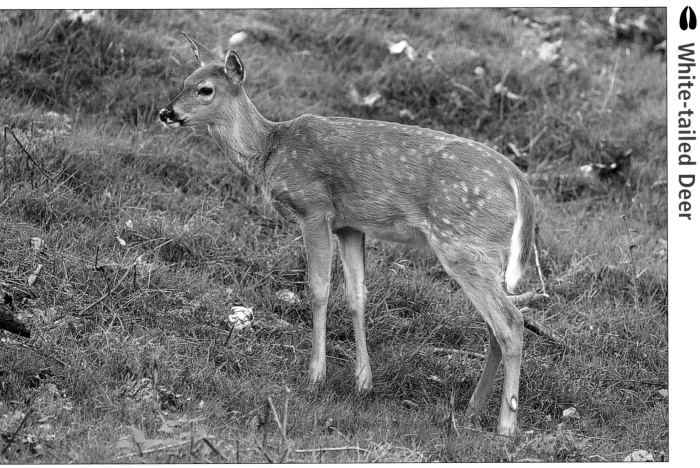

White-tailed deer, fawn (August/British Columbia)

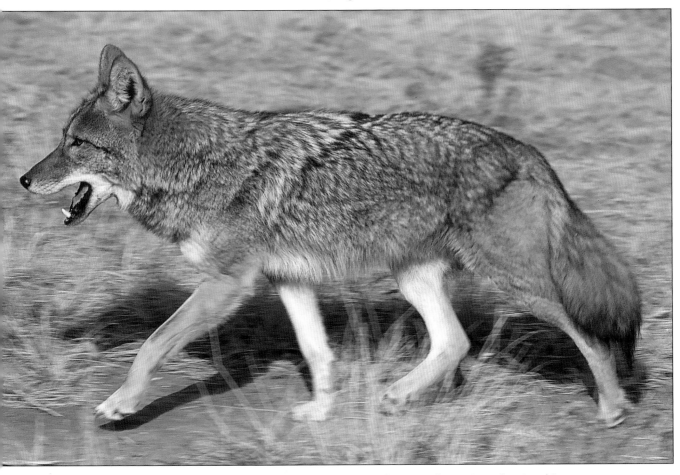

The coyote is probably North America's main deer predator (October/Utah).

- There are 30 recognized subspecies of the white-tailed deer. It is estimated that there are about twenty million white-tailed deer in North America.

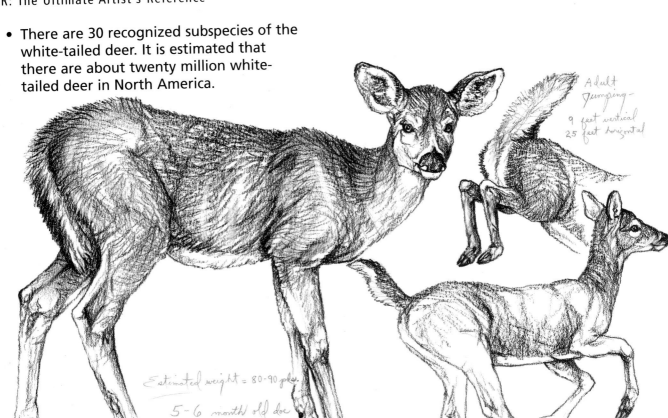

Estimated weight = 80-90 pds.

5 - 6 month old doe

Minnesota / October

Adult Jumping—

9 feet vertical
25 feet horizontal

Top speed = 35-40 mph

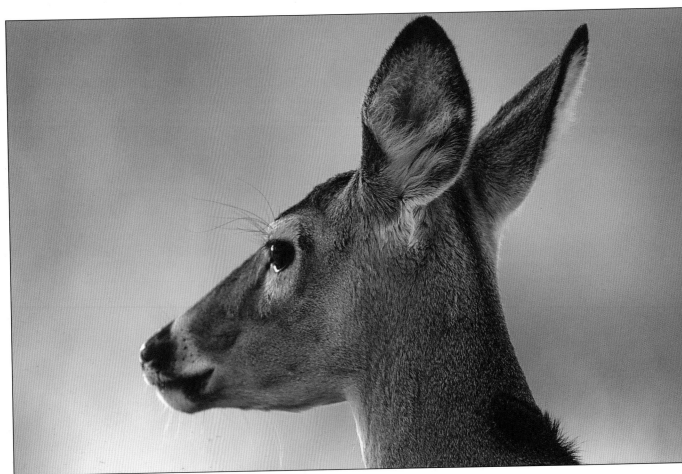

White-tailed deer, doe (September/Mexico)

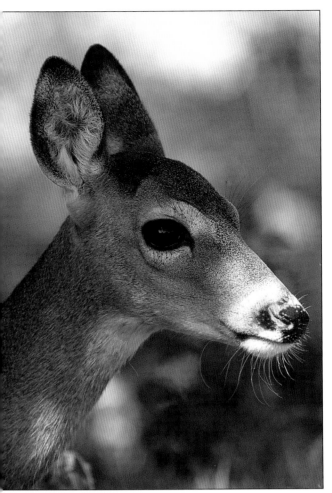

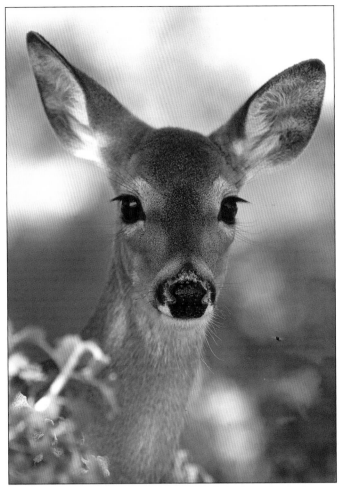

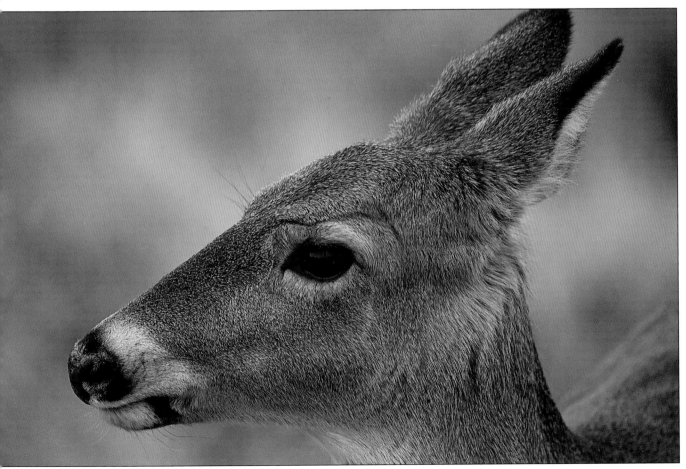

White-tailed deer, does (Top: Immature doe, Texas. Bottom: October/Minnesota)

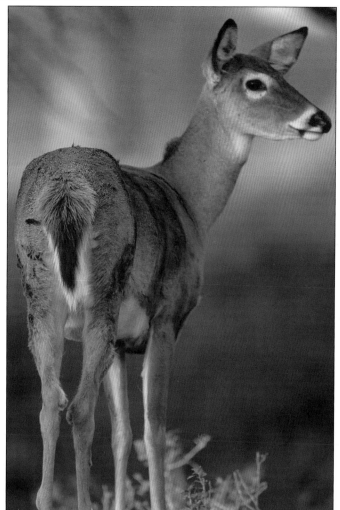

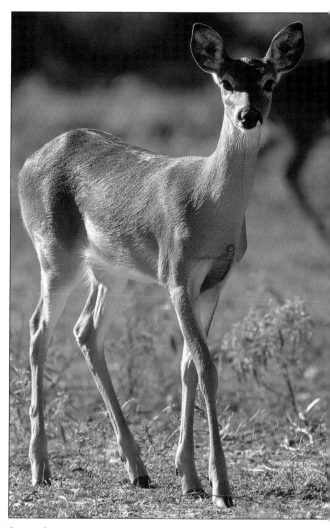

White-tailed deer, does

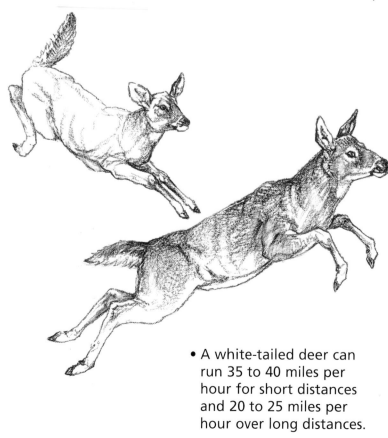

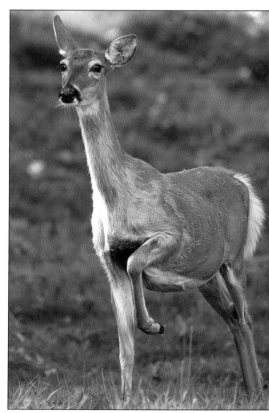

• A white-tailed deer can
 run 35 to 40 miles per
 hour for short distances
 and 20 to 25 miles per
 hour over long distances.

Stamping a foot in alarm is a doe's way o
showing trouble is nearby.

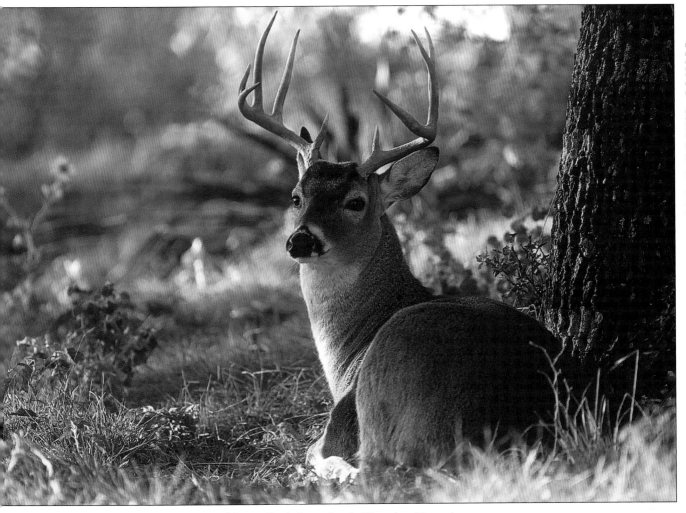

White-tailed deer, buck (October/Texas)

• Deer ears are often "cocked" back and forth in order to pinpoint a dangerous-sounding noise.

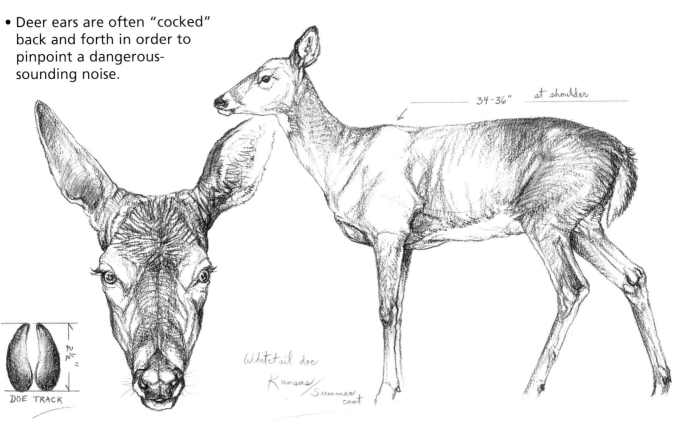

34-36" at shoulder

Whitetail doe
Kansas/Summer coat

DOE TRACK

2½"

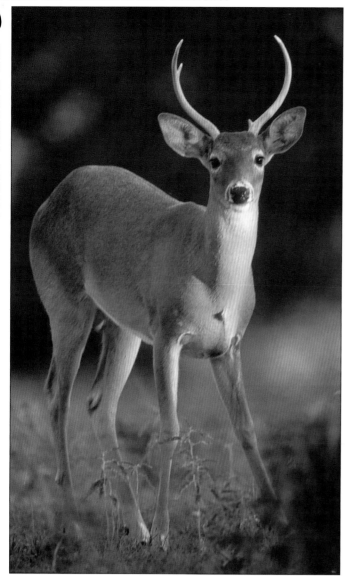

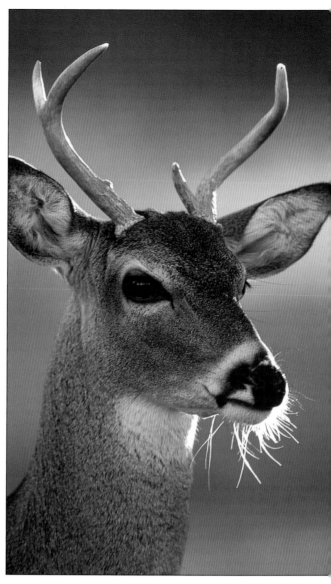

White-tailed deer, bucks (October/Louisiana). Note the face whiskers.

• Southern deer are smaller than northern deer species.

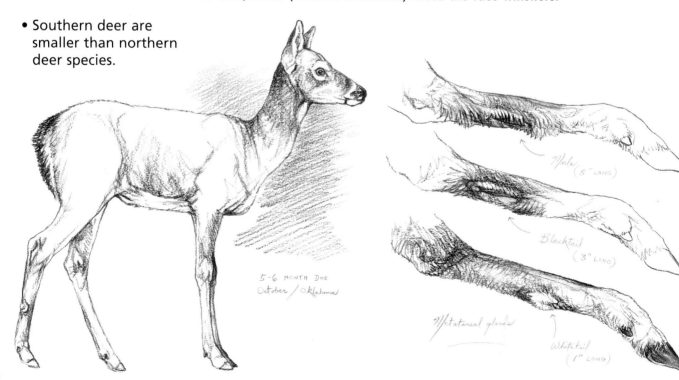

5-6 MONTH DOE
October / Oklahoma

Mule
(5" LONG)

Blacktail
(3" LONG)

Metatarsal glands

Whitetail
(1" LONG)

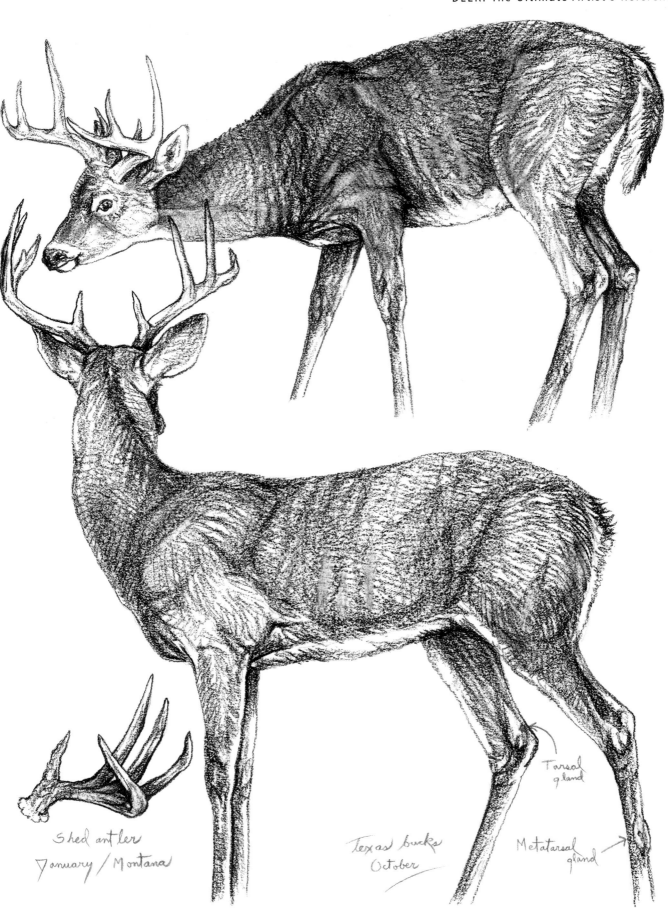

Shed antler
January / Montana

Texas bucks
October

Tarsal
gland

Metatarsal
gland

• The conformation of antlers is hereditary. These
characteristics, however, may not be fully evident
until the deer is at least three years old.

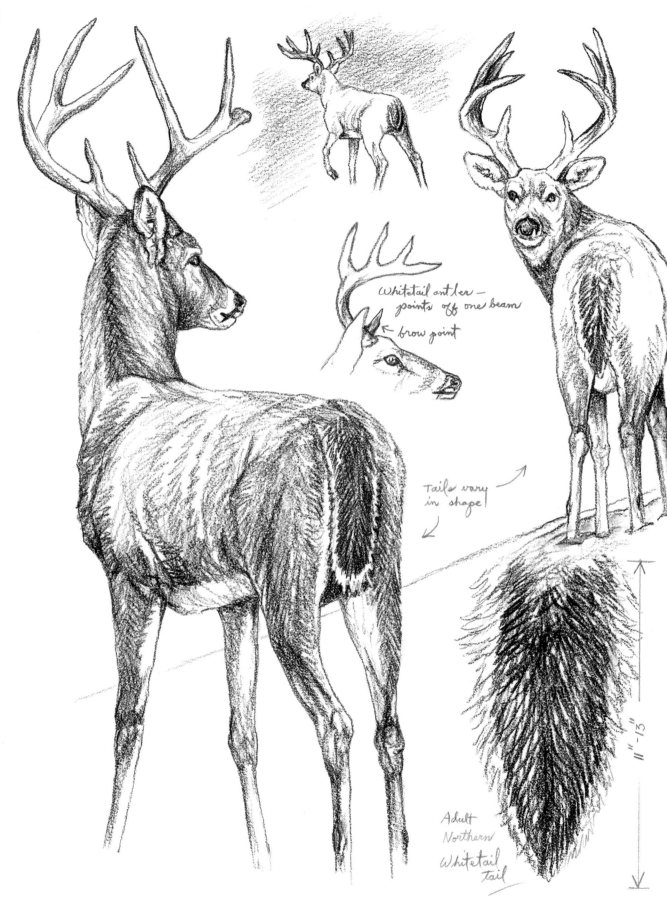

Whitetail antler — points off one beam

brow point

Tails vary in shape

11"–13"

Adult Northern Whitetail Tail

• White-tailed deer bucks can have brow tines of eight inches or more. The first tine of an antler is usually the short brow tine, and the second is the longest, with each succeeding tine being a little shorter.

• Texas has more deer than any other American state.

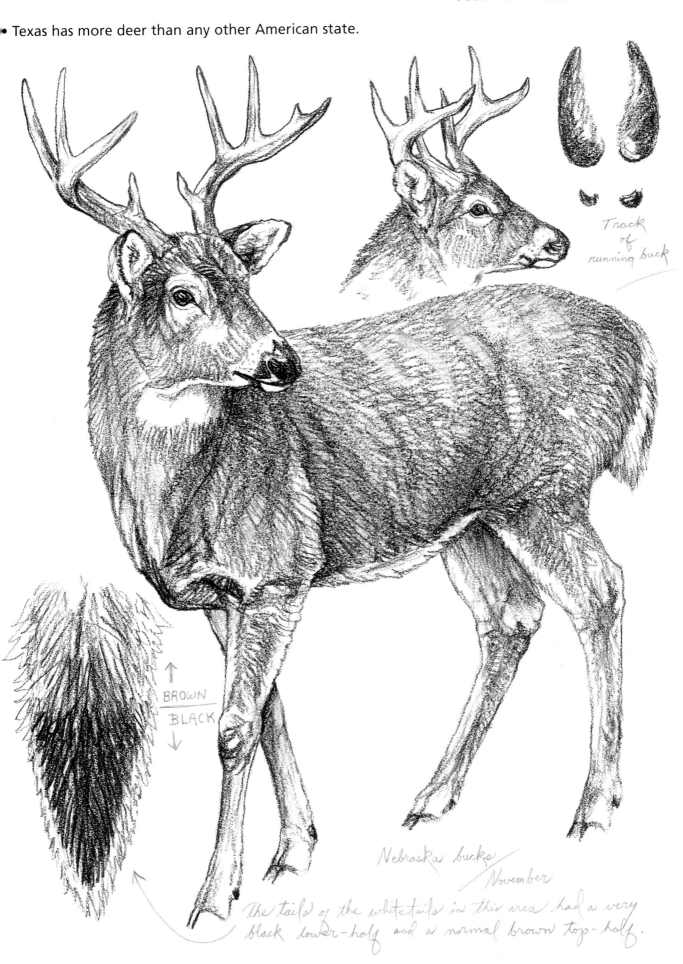

Track
of
running buck

↑
BROWN
BLACK
↓

Nebraska bucks
November

The tails of the whitetails in this area had a very
black lower-half and a normal brown top-half.

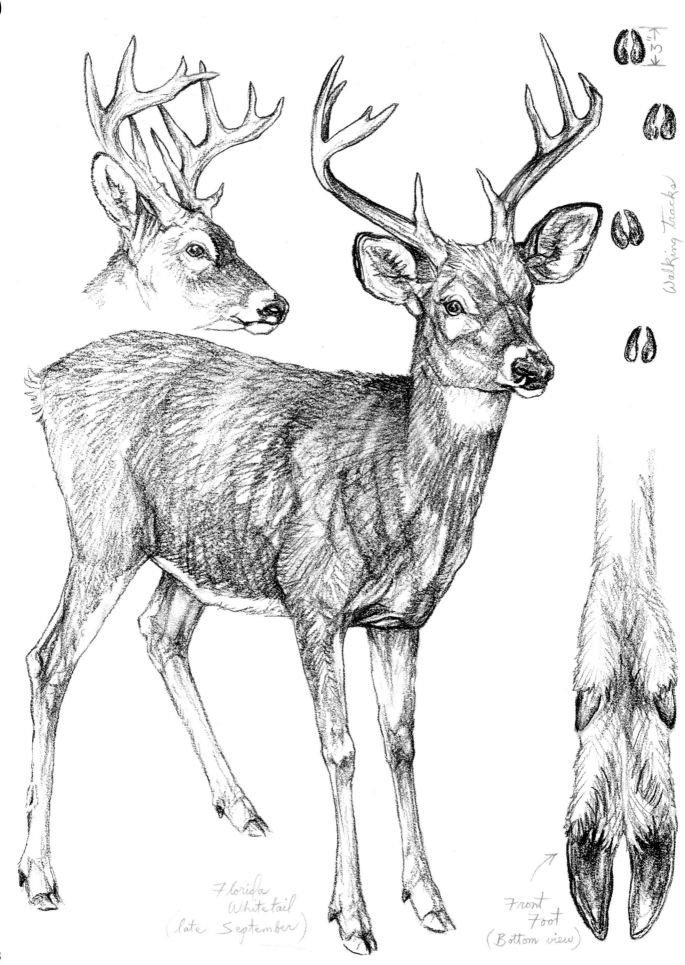

Florida
Whitetail
(late September)

Front
Foot
(Bottom view)

Walking Tracks

3"

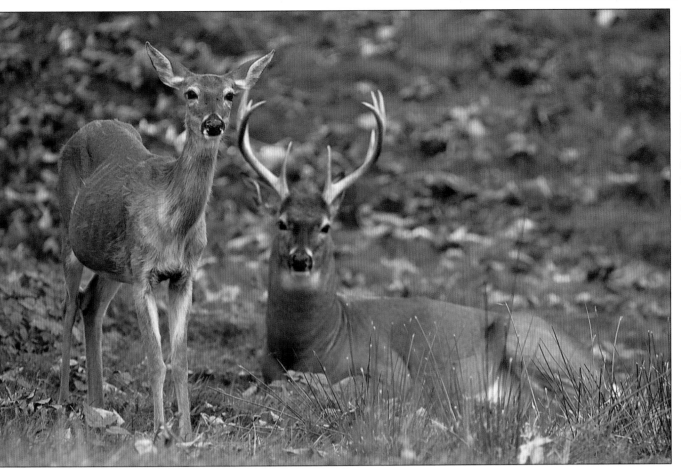

White-tailed deer, doe and buck

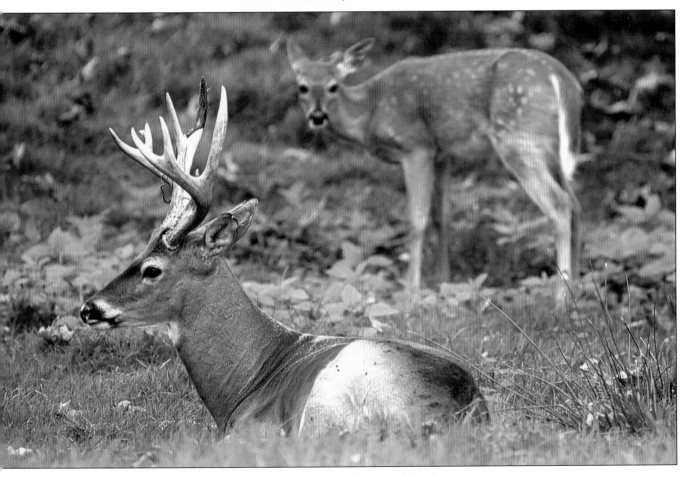

White-tailed deer, fawn and buck

• A white-tailed deer can easily jump over eight-foot high fences and can clear twenty-plus foot spans in between strides.

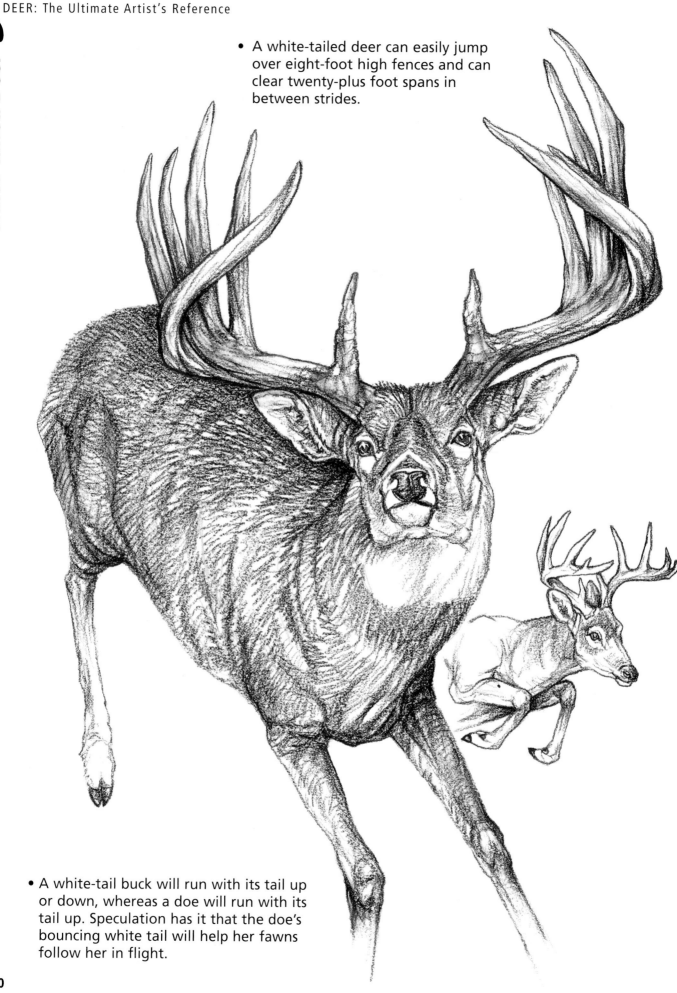

• A white-tail buck will run with its tail up or down, whereas a doe will run with its tail up. Speculation has it that the doe's bouncing white tail will help her fawns follow her in flight.

White-tailed Deer

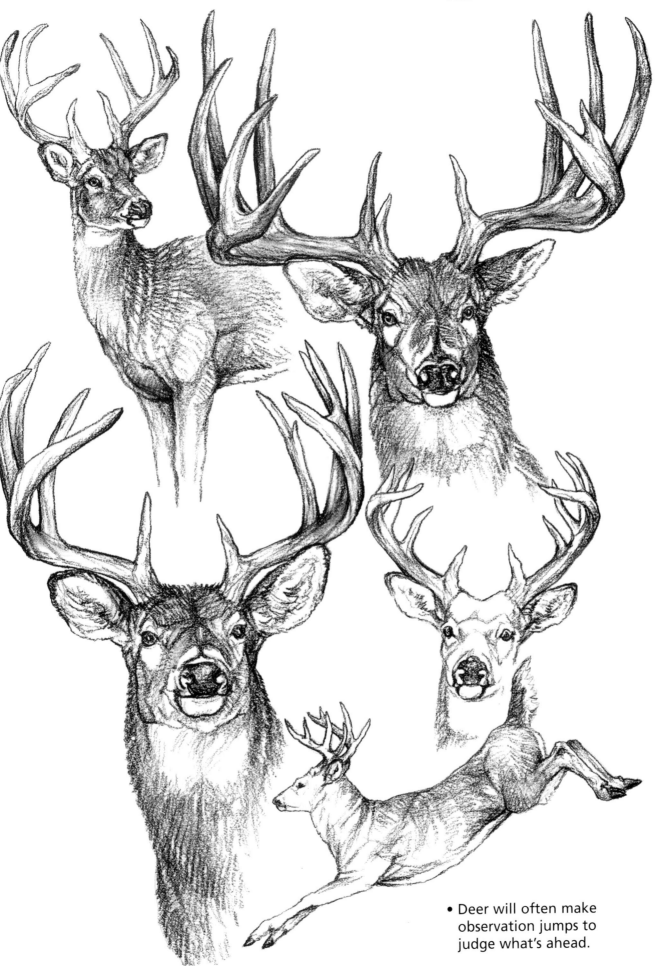

• Deer will often make observation jumps to judge what's ahead.

White-tailed Deer

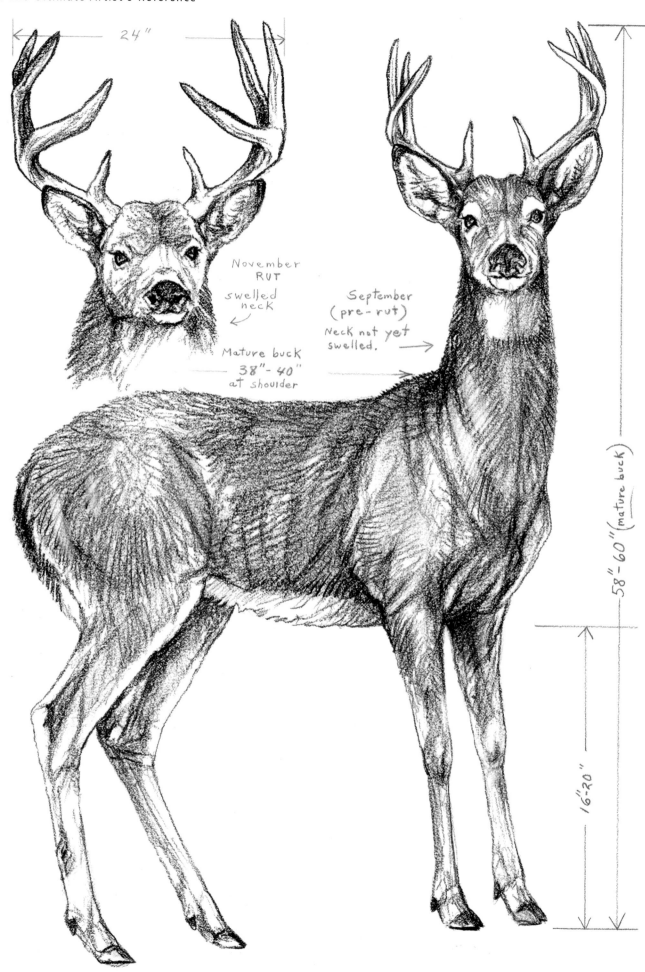

24"

November
RUT
swelled
neck

Mature buck
38"- 40"
at shoulder

September
(pre-rut)
Neck not yet
swelled.

58"- 60" (mature buck)

16"-20"

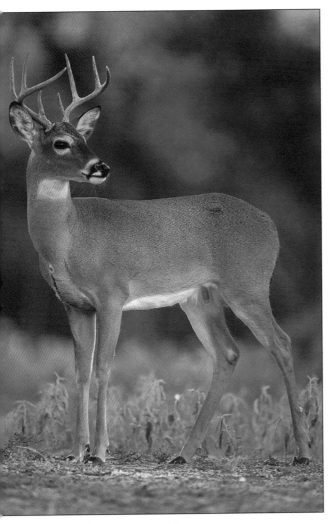

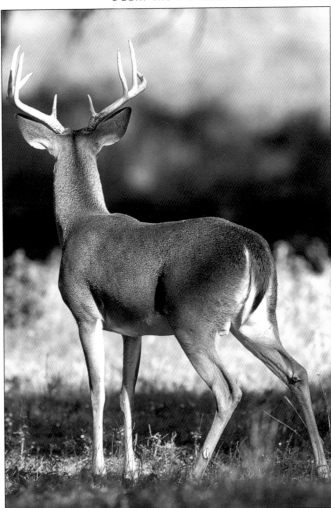

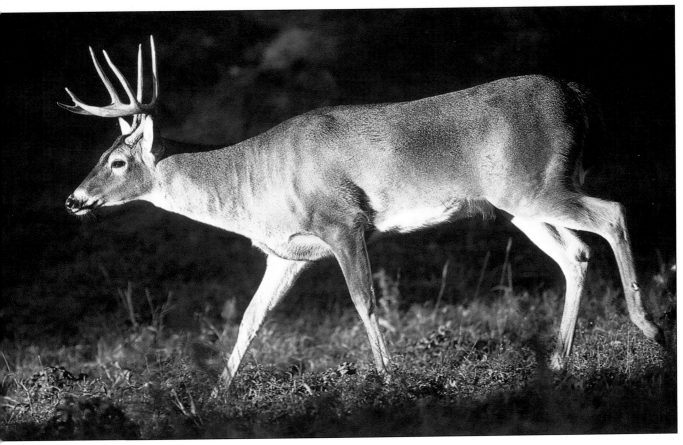

White-tailed deer (October/Oklahoma)

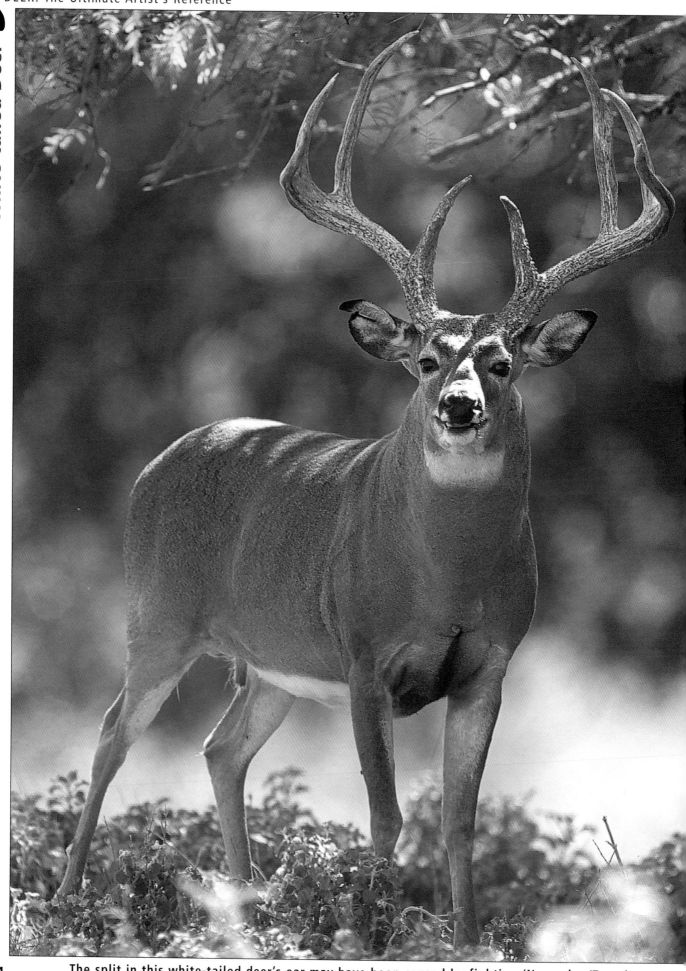

The split in this white-tailed deer's ear may have been caused by fighting (November/Texas).

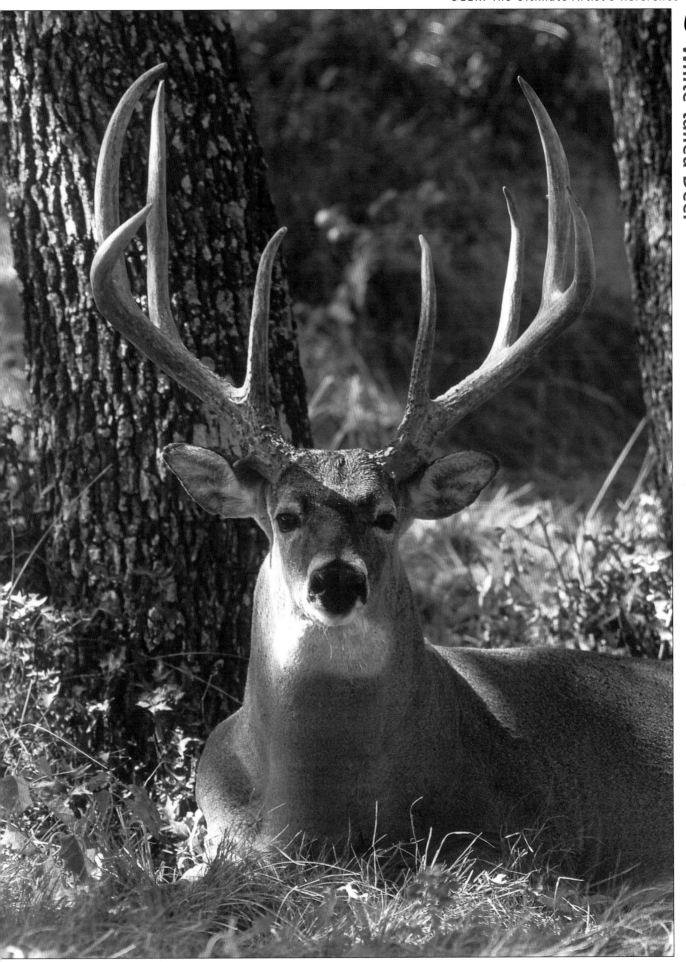

This white tail sports a superb eight-point rack (November/Texas).

White-tailed Deer

• The white-tailed deer's first antlers are usually a "spike."
A healthy three-year-old buck will usually have eight points.

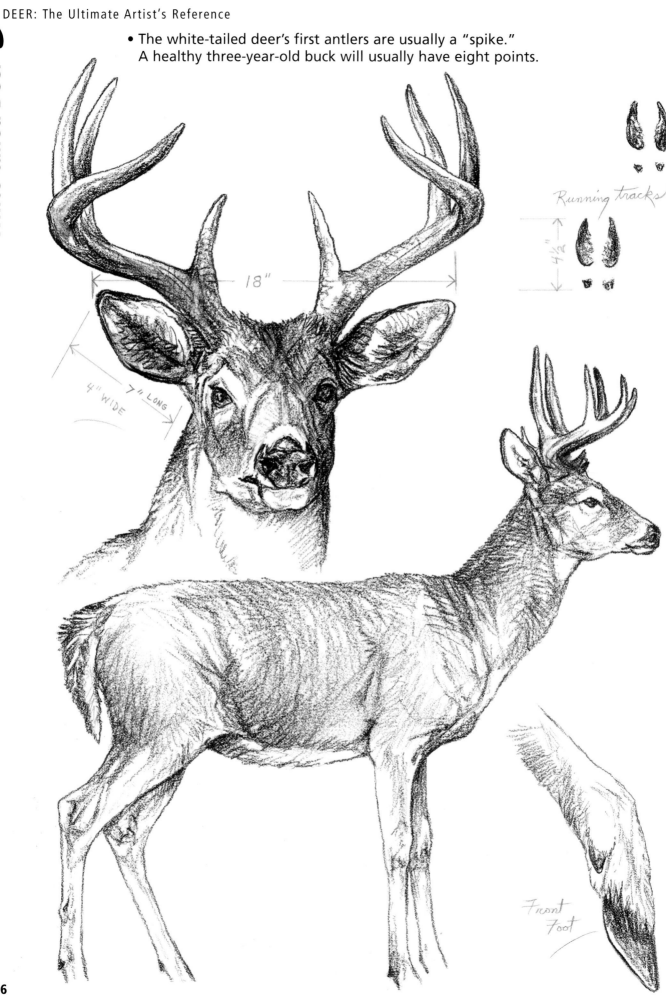

18"

4" WIDE 7" LONG

Running tracks

4½"

Front Foot

96

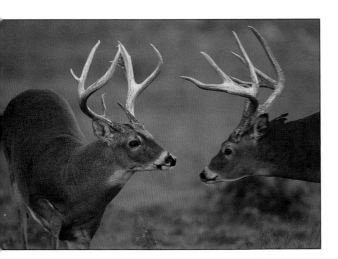

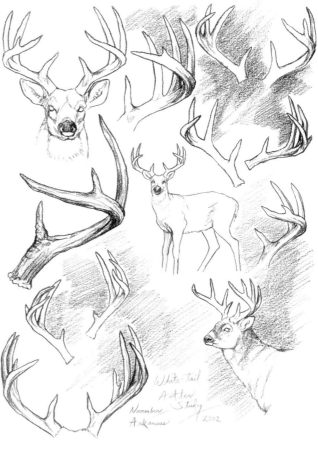

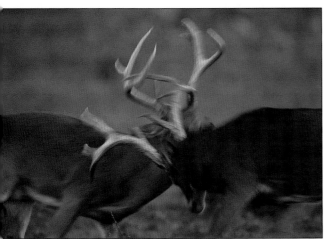

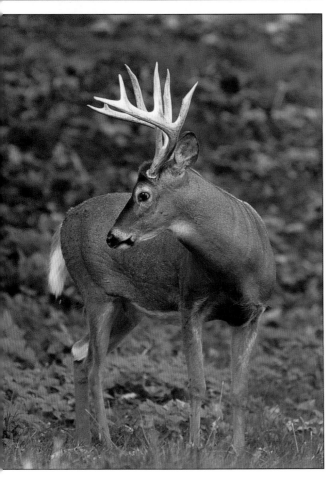

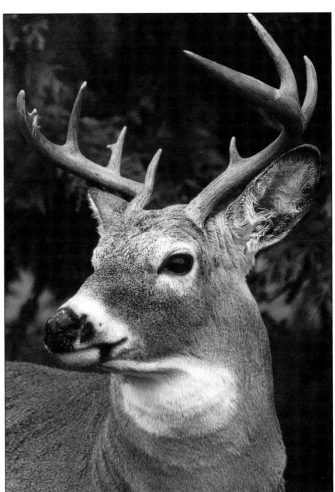

White-tailed deer (Top left: Fighting bucks, October/Texas)

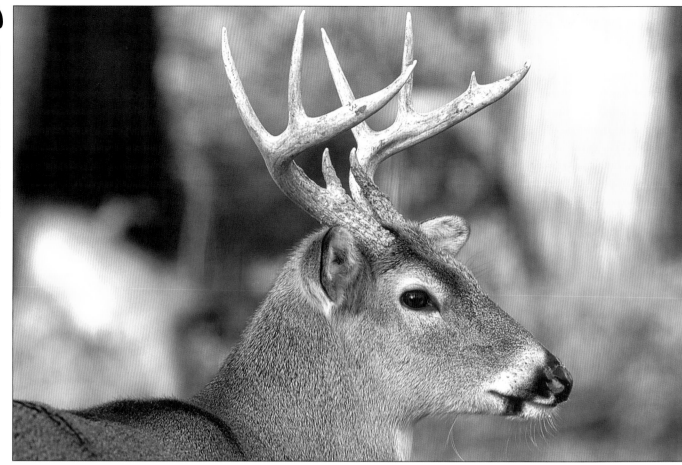

White-tailed deer, buck (October/Iowa)

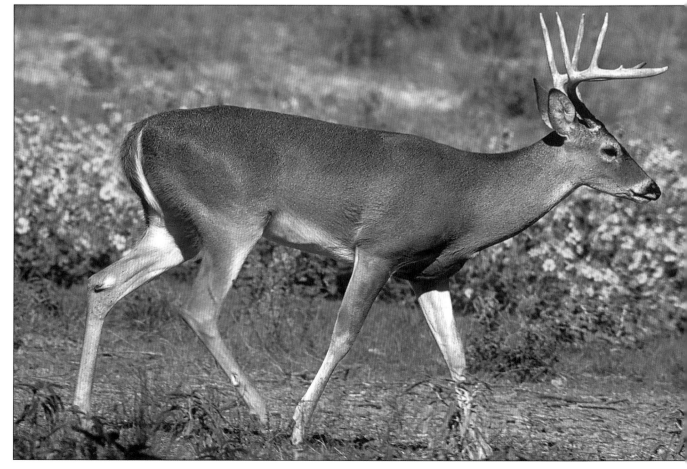

White-tailed deer, buck (October/Texas)

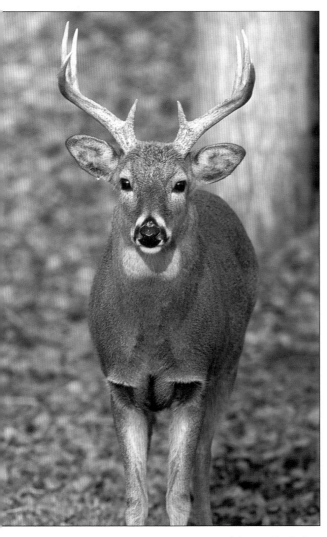

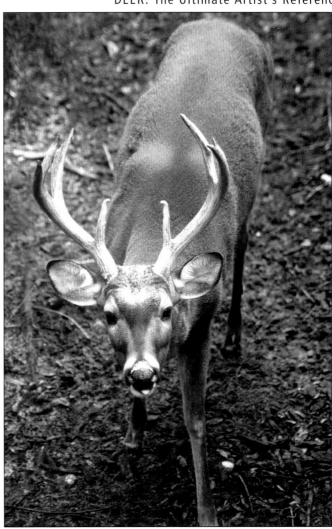

White-tailed deer, bucks (November)

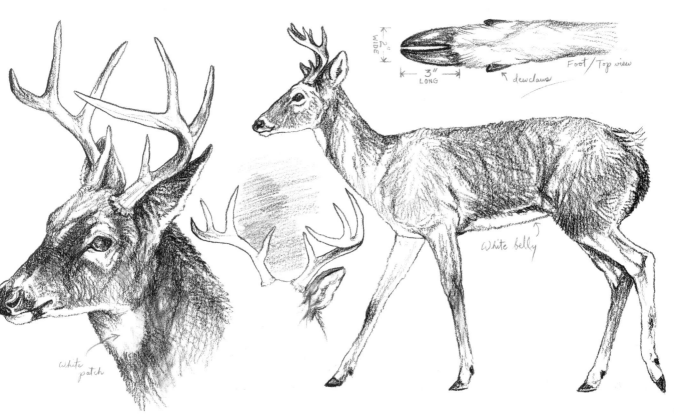

2" WIDE

3" LONG

Foot/Top view

dewclaws

white patch

white belly

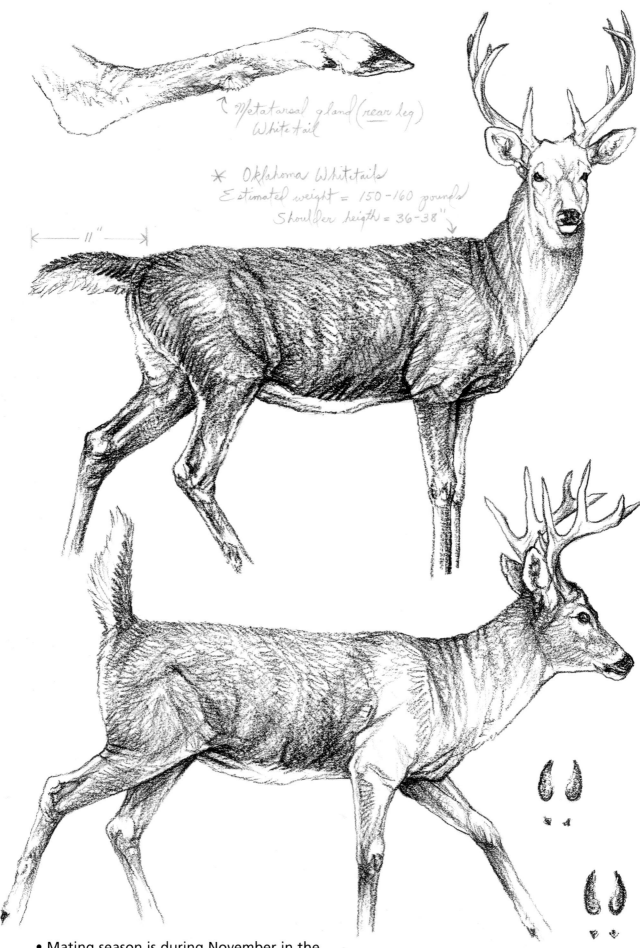

Metatarsal gland (rear leg)
White tail

* Oklahoma Whitetails
Estimated weight = 150-160 pounds
Shoulder height = 36-38"

← 11" →

• Mating season is during November in the
 north and January and February in the south.

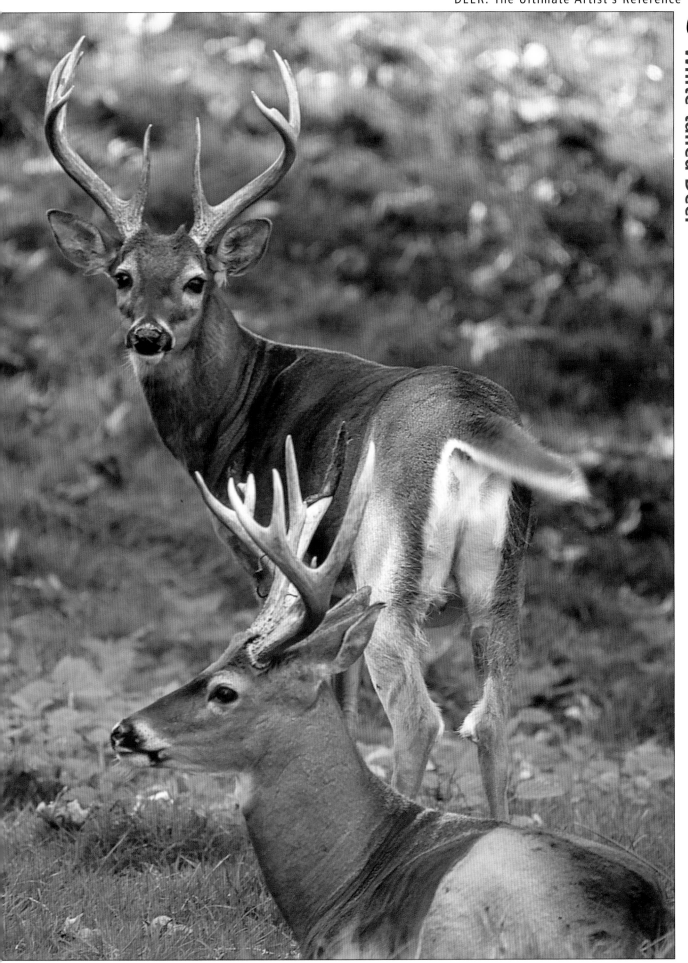

White-tailed deer, bucks (September/British Columbia)

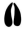

• A large buck of the northern white-tail species will often weigh over 300 pounds.

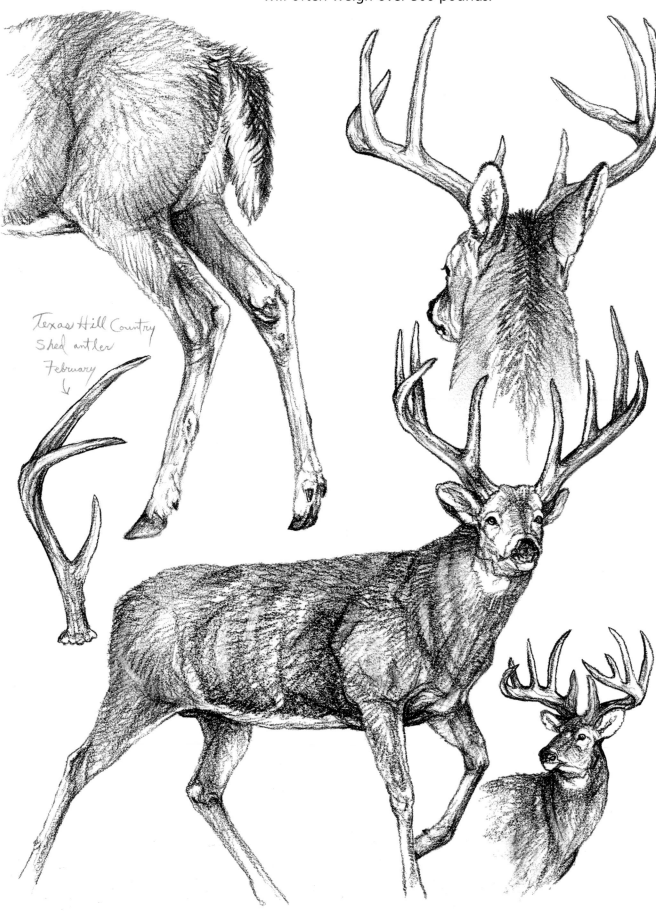

Texas Hill Country
Shed antler
February

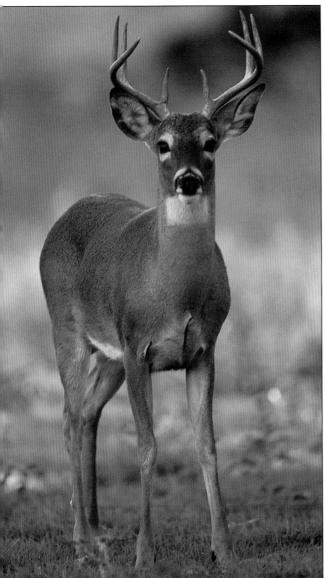

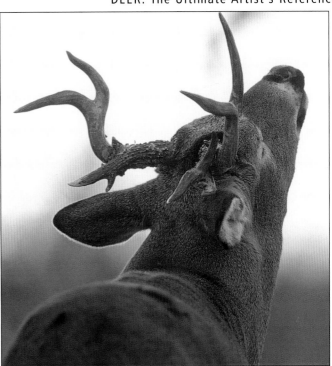

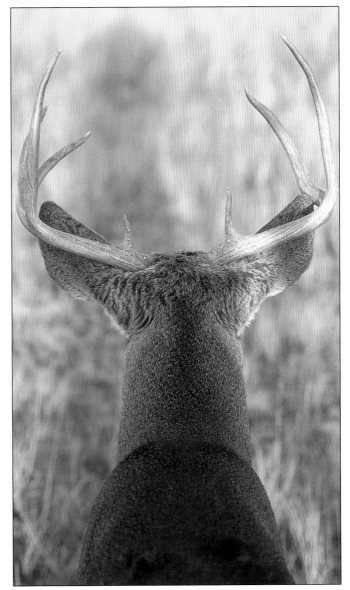

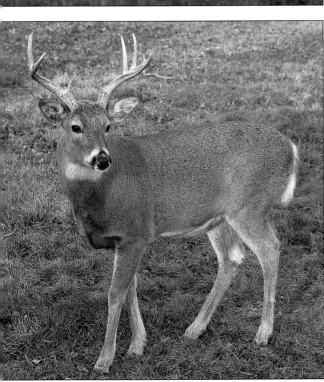

White-tailed deer, bucks (October)

White-tailed Deer

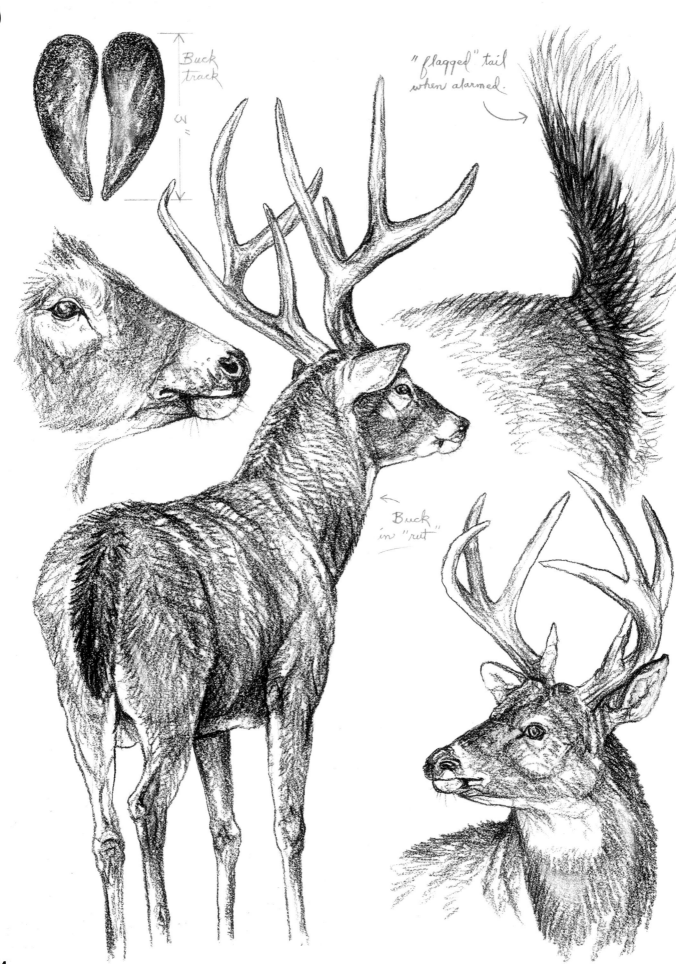

Buck track 3"

"flagged" tail when alarmed.

Buck in "rut"

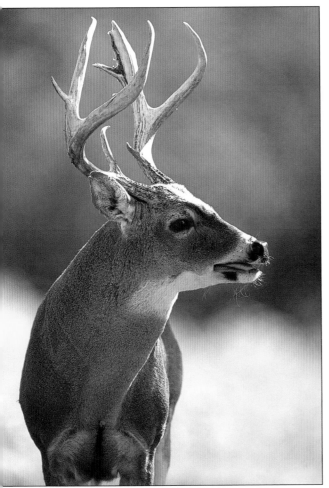

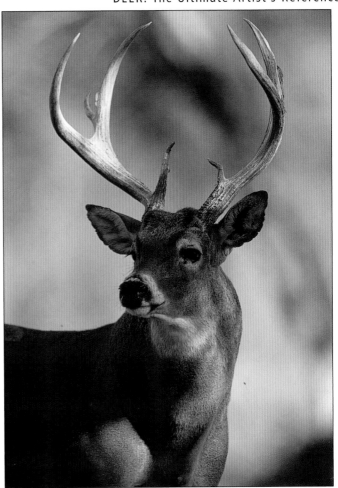

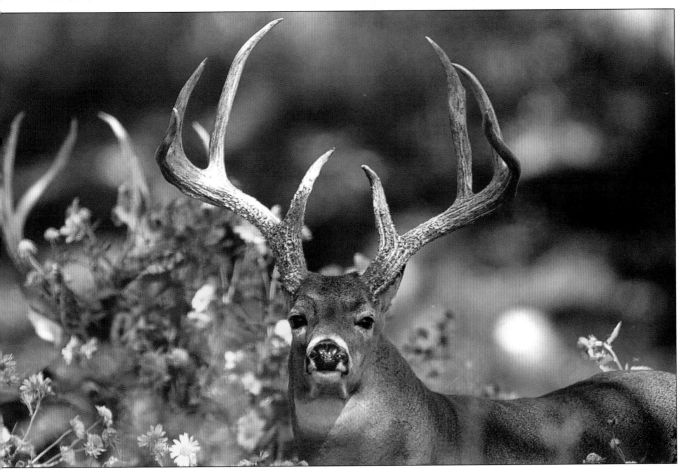

White-tailed deer, bucks (October/Texas)

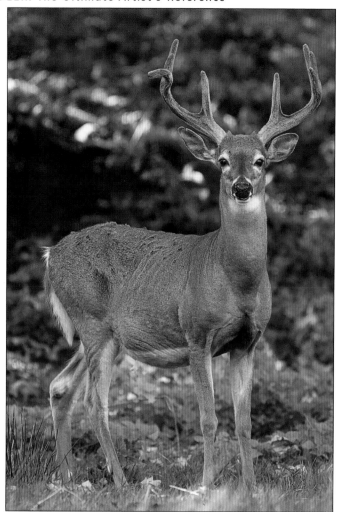
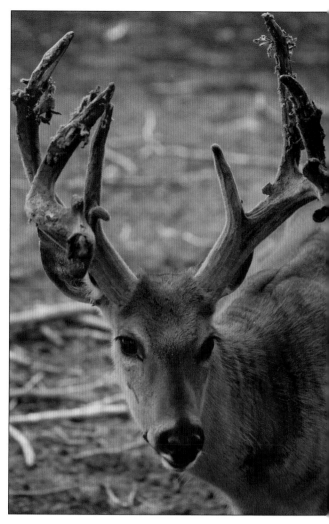

Bucks in velvet (September/Alberta)

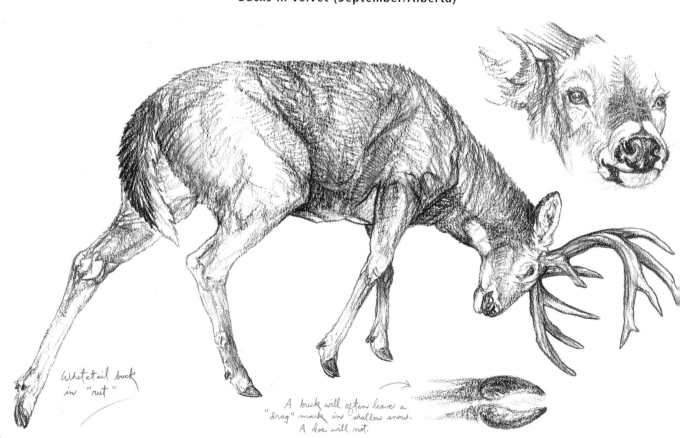

Whitetail buck in "rut"

A buck will often leave a "drag" mark in shallow snow. A doe will not.

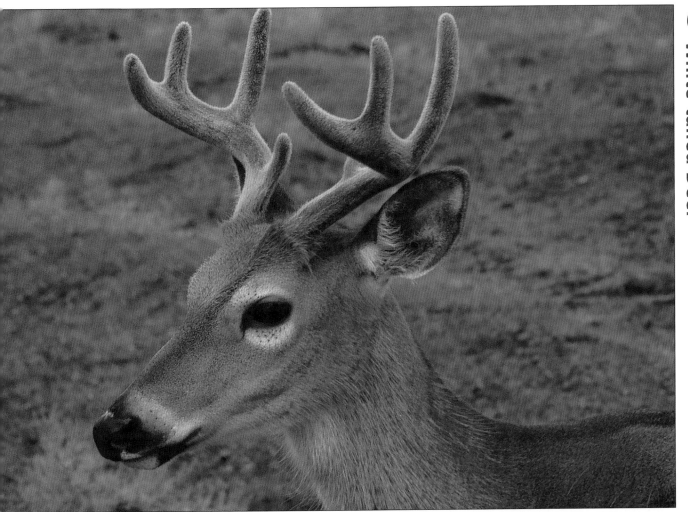

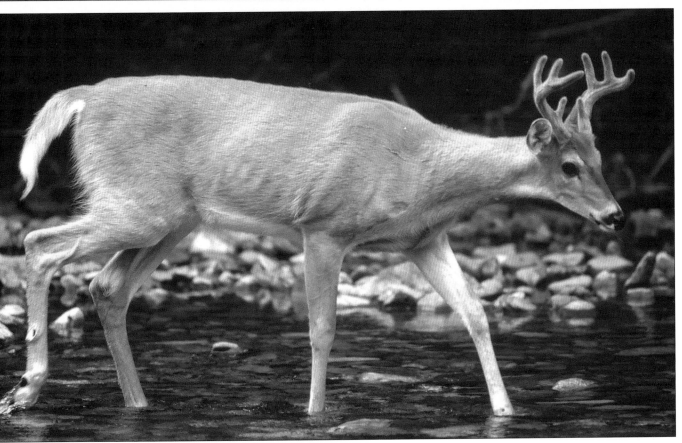

White-tailed deer, bucks (September/Montana)

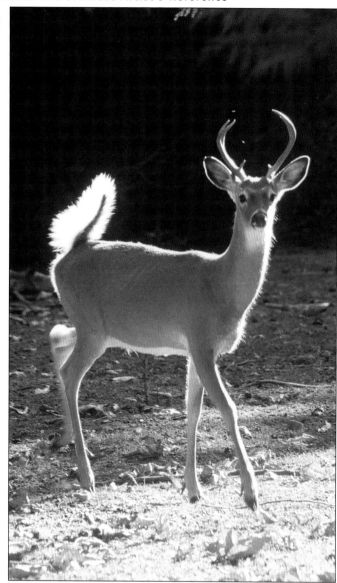
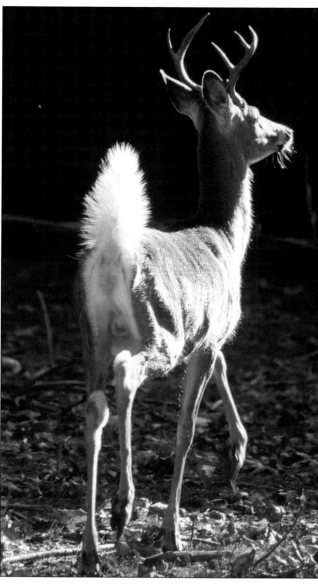

White-tailed deer, bucks (November/Alabama). Notice the tails flagged in alarm.

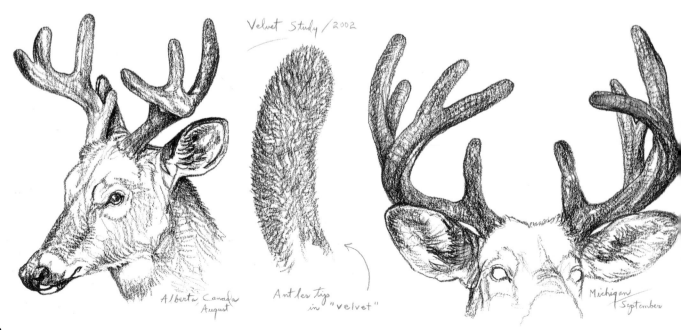

Velvet Study / 2002

Alberta Canada
August

Antler tips
in "velvet"

Michigan
September

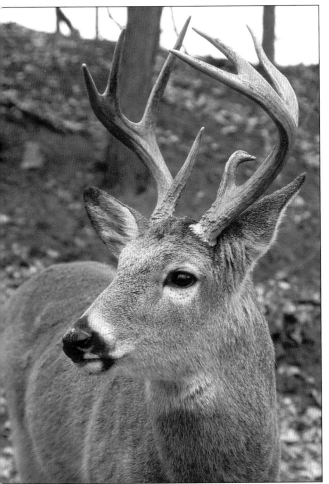

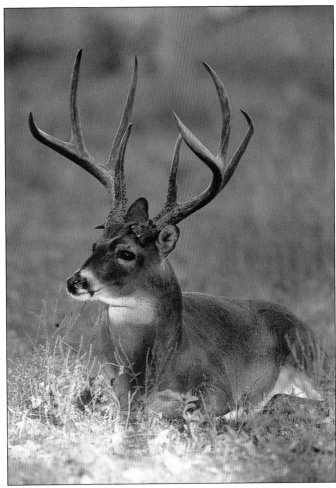

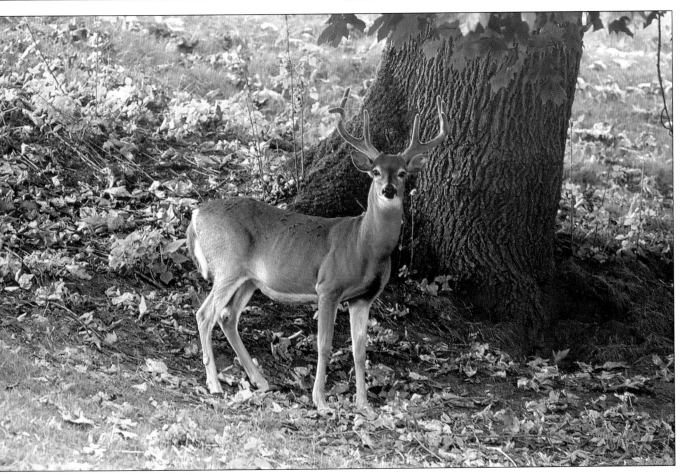

White-tailed deer, bucks

White-tailed Deer

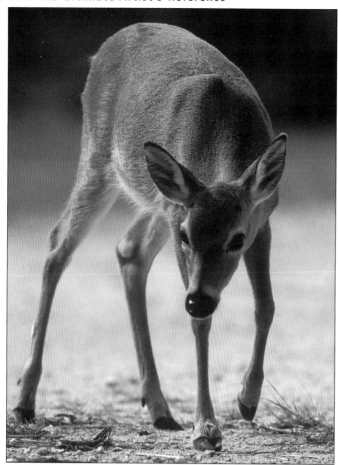

The Coues' deer of the Arizona desert and Mexico, and the Key deer of the Florida Keys are the smallest species of white tails. The largest bucks will not weigh even 100 pounds.

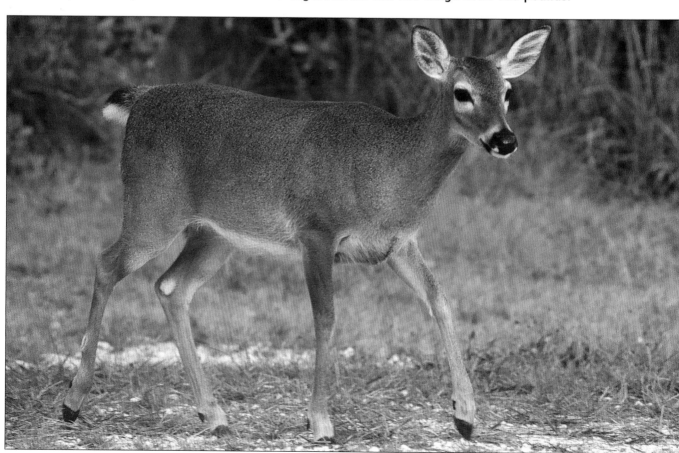

White-tailed deer, Key deer subspecies, immature (November/Florida Keys, Florida)

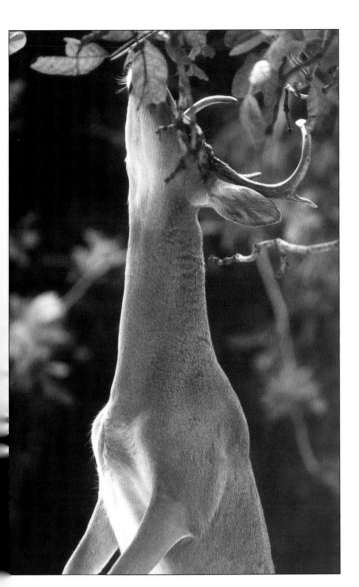

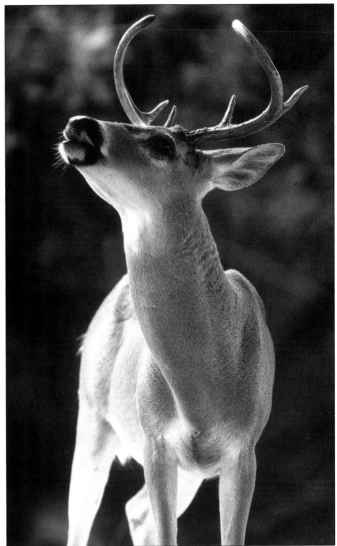

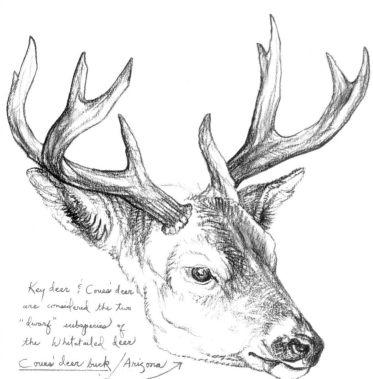

Key deer & Coues' deer
are considered the two
"dwarf" subspecies of
the Whitetailed deer
Coues' deer buck / Arizona →

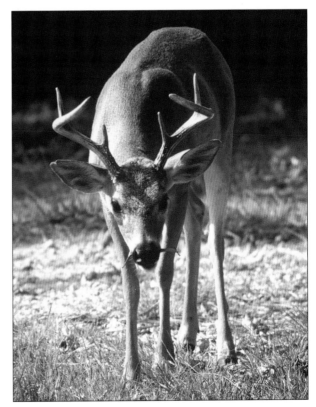

White-tailed deer, Key deer subspecies, bucks (November/Florida Keys, Florida)